léger

léger

André Verdet

Hamlyn

London New York Sydney Toronto

twentieth–century masters
General editors: H. L. Jaffé and A. Busignani

© Copyright in the text Sadea/Sansoni Florence 1969
© Copyright in the illustrations SPADEM Paris 1969
© Copyright this edition The Hamlyn Publishing Group Limited 1970
London · New York · Sydney · Toronto
Hamlyn House, Feltham, Middlesex, England
ISBN 0 600 33406 6

Colour lithography: Zincotipia Moderna, Florence
Printing and binding: Cox and Wyman Limited
London, Fakenham, and Reading

Distributed in the United States of America by Crown Publishers Inc.

contents

List of colour illustrations

List of black-and-white illustrations

The Léger studio

Ever since his youth Fernand Léger has had a group of followers. His teaching career began in 1924 at the Académie de l'Art Moderne where he taught together with Marie Laurencin, Amédée Ozenfant and Exter.

Later on, when Ozenfant moved to the Avenue Reille, Léger assumed sole artistic direction of the studio, which remained at the same address, 86 rue Notre-Dame-des-Champs, until 1930. After the artist's short spell at the Académie de la Grande Chaumière, from 1932 to 1933, the studio reopened, first in the rue de la Sablière, then in the rue du Moulin-Vert, and finally in Henry Delormel Square, where it was to close on account of the war.

It was during this period that Roland Brice, later to become Léger's ceramic assistant, and Nicolas de Stael came to work at the studio, where they had the opportunity of involving some Renault workers for whom some special courses had been organised following a lecture by Léger at Boulogne-Billancourt.

In 1945, even before Léger's return from the United States, the studio reopened, first at Montrouge and then in the Boulevard de Clichy, in Montmartre. The number of students made larger premises necessary; young artists of every race and nationality came to work there from all parts of the world.

Friday was the day spent in reviewing the week's work; the studio was crowded, students and visitors alike following the *patron* around, the new ones nervous of showing their work for the first time, those who had been there longer more at ease and self-possessed. Léger would arrive about eleven o'clock, a mackintosh thrown over his shoulder and with a piece of greenery gathered on the way.

He always showed his pleasure at the sight of the crowd awaiting his arrival. Friends from long ago often visited him—one day Paul Eluard turned up and followed the review of the work with great interest and attention. But the comments that Léger made and the advice he gave unstintingly to the students for hours on end were none the less instructive for the presence of his old friends.

Anyone who did not know Léger, who judged him solely from appearances, could have had no idea of his kindly and sensitive nature, belied by a gruff countenance that seemed to act as a protective shield for his real character. His profound humanity showed itself in a smiling bonhomie that characterised the whole of his review of the week's work. He always found the right word of encouragement for the student whose work he had just marked; the more experienced knew that the meaning of his 'joli' (pretty or attractive) was the equivalent of condemnation—while 'c'est costaud' (beefy, strong) was the greatest compliment he could bestow.

'Remember' he would often say, 'Painting is a demanding profession, needing determination, patience and courage. If you are not up to it, then choose something else. It is a tough struggle which endures for a lifetime, sparing nobody, not even us elders.'

And he would add, 'You have come to work here of your own choice. Do not be afraid of falling under my influence. We have all passed through that phase. Nothing falls from the heavens and nobody was born a genius. I for my part was influenced by Cézanne. Then one fine day I had had enough of him. It is up to you to do the same, to decide when you have had enough of Léger, conserving from your passage through the studio only what you consider to be useful for the development of your personality.'

Léger never sought to impose his own view of the world and of things just as he never imposed his own pictorial style on his students. He sought above all to lay bare the underlying cause of the deficiencies or errors in the works submitted to his critical eye, and to bring out their potential, but always with regard to the character of each individual student. The diversity of the artistic tendencies, whether towards abstraction, surrealism or figurative painting, and the variety of the techniques employed demonstrated the complete freedom that Léger sought to preserve. 'Do not expect that it will provide a solution, that it will enable you to find the way out. That would be too simple. The problem is inside yourselves. So far as I am concerned, I can see my salvation. It is up to you to find yours.' Nevertheless he always laid an emphasis on the importance of drawing. 'Draw, above all draw', he recommended. 'A precise drawing, a drawing of lines, nothing else but lines. First details, hands, feet, then whole figures, and finally entire compositions.'

He expressed his admiration for the Primitives, for David and Ingres, and his dislike for the painters of the Renaissance and for Delacroix. 'Every age has a realism of its own', he wrote in 1938 in the preface to a catalogue of an exhibition of his pupils' work. 'That of Impressionism is different from our own. The most overt formal characteristic of our age is the liberation of the object in terms of its aesthetic significance. There is a value in the object itself which must be brought out. This is the new realism. In the past the subject has been the framework in which the object is described; now we have so defined the latter that it becomes the principal framework of modern paintings. It may be that we are discovering new subjects, but they will not be valid unless they can be judged against the primacy of the object itself. In this modern development drawing takes a new place. Drawing above all. Then colour. This will be the new order.'

In 1951, the future of painting was envisaged in this way:
'An abstract art that must adapt itself to walls.
A monumental art that anticipates walls.
The easel painting continues on its own path.
Reappearance of figures, human bodies, eyes and legs, which arrange themselves in contemporary or social themes.
A return to the collective life.
These are the paths which today lead to modern paintings.'
Léger liked to be with the young who enchanted him with their enthusiasm and passion. 'What abundance there is in youth', he would say. 'They work hard: it is a challenge. But, you know, while I may give them something, they also give me a great deal; it is an exchange.'

Those who were not aware that the name 'master' was not at all to his liking were taken aback by his simplicity and cordiality.

He would often ask us to lunch. When with his students, with his 'équipe' as he called the older ones among us, including Roland Brice, Davos Hanich, Carlos Carnero and myself, he evinced such youthfulness, such ambitious projects for the future, that he was really the youngest among us.

Concerned as he was about the material difficulties which the majority of his students faced, he would sometimes through a handshake slip help to someone who for days had been living on bread and margarine.

He would dream of the great painting shops of the Middle Ages, in which the apprentices covered the walls with fresco or mosaic under the direction of the *patron*.

But what has been the fate of those who worked for months on end in the studio? The majority are scattered once more around the globe. A few stayed on in Paris and are successfully continuing their tough profession as painters: Fonfreide, Schwartz, Caracalos, Nemours, Raymond Abner, Macris, James Taylor, Koskas, Damian, Enard, Maussion, Yves Faucheur, Davos Hanich, Carlos Carnero, Faniest, and Wallich, while Roland Brice has devoted himself to ceramics.

Each one of them, each one of us, retains a precious memory of a great artist and painter, who was at the same time straightforward, infinitely kind, a friend of the young, in short a really great man.

GEORGES BAUQUIER

Le seul homme de génie qui air été capable d'introduire l'image du travail dans la peinture véritable.
ANDRE MALRAUX

The Léger museum

On the 4th February 1969, André Malraux, then Minister of Culture in France, came in person to Biot officially to accept the donation which Nadia Léger, the widow of the artist, and Georges Bauquier, formerly Director of the Léger studio in Paris, wished to make to France. The donation consisted of one of the most beautiful buildings on the Côte d'Azur, the museum devoted to the work of Fernand Léger, that master of pure colour and precise form, of space and contrast.

The day André Malraux had chosen to take possession, in the name of the French Republic, of the building and the many works it contains, was the 4th February, the artist's birthday–he was born on February 4th, 1881. This was in fact a pilgrimage to honour an old friend as much as an official duty for Malraux. The latter had not forgotten the bonds of friendship that linked him to the artist, nor that Léger had, forty years earlier, illustrated one of his poems–*Paper Moons*.

In 1960 Malraux declared during a visit to the museum that the vast ceramic frieze which adorns its façade was more beautiful and serene than the majestic example at the University of Mexico. The donation comprised the principal building, the subsidiary structures and the land around, but also and especially the 285 works by Léger himself, which included forty-eight paintings, sixty-eight gouaches, a few dozen drawings and lithographs, thirty-odd ceramic pieces, a number of bronzes and some tapestries. The paintings include some of his greatest and best-known masterpieces. In terms of the present-day values of Léger's work the whole donation is worth something approaching fifty million new French francs. This then is an exceptionally generous donation, in all senses of the word.

It was a little time after her husband's death that Nadia Léger decided to have a building constructed to house the collection of his work. At first she thought of using the house which the Légers owned in the Vallée de Chevreuse, not far from Paris at Gif-sur-Yvette; but she later decided to construct a new building for the purpose at Biot, on the very plot of land that Léger himself had chosen for the creation of his great polychrome ceramic sculptures, freestanding forms, which were the artist's main concern at the time of his death.

This conception of mural sculpture and of monumental sculpture had grown in Léger to the point where it became obsessive. This came about through the complete mastery of his artistic imagination, and through

the emergence of that pictorial dynamism, his constant artistic purpose which was beginning to undermine the foundations of Cubist and post-Cubist painting.

Léger's genius continues to exist at Biot through and in his work. In the appropriately functional building, designed to show off the works in a clear and uniform light, the paintings and sculptures come to play an integral role in the architecture. This is one of the most definite characteristics of the museum as a whole. If Fernand Léger could see it today (the Léger who claimed to have learnt more from a 75 mm gun barrel in full sunlight than from all the museums in the world) he would certainly see it as a tangible realisation of many of his hopes and visual ideals, in an environment that is both collective and public. This temple of art, in which painting, sculpture and architecture combine forces in a joint harmony is an environment in which man may approach that total beauty which his nature implies and which sometimes exists within himself.

Fig. 1 A whole hill was transformed for the creation of the museum in order to arrange and balance the forms of the building in an entirely re-created environment. André Svetchine's design, forty-five metres long and thirteen deep, is an imposing one. It is dominated by the four hundred square metres of the ceramic relief (Léger made a sketch for its design, for the Hanover Olympic Stadium), and by the glass of the entrance hall which is nine metres high and seven broad. The huge polychrome ceramic sculpture *Jardin d'enfance,* judiciously placed on the left of the façade, stands in the open air against the breadth of the terrace and the green lawn. I think that Léger would have placed himself right here to view the vast façade, whose forms and colours seem to combine in a dynamism that communicates itself to the surrounding open space, with a truly Olympian enthusiasm. This is just as he had conceived it and set it out in his drawing, as a first sketch.

Beyond the limits of painting

Fernand Léger, born in Normandy, who continued to love his homeland in spite of the fact that his heart was bound to Paris for so many years, whose art is as a whole so happy and sunny, had for long been distrustful of the Mediterranean and its sun. Then gradually, and especially through repeated stays at Biot, where he had found a studio that was suitable for the creation of ceramic sculptures, his distrust for the land of the southern sun was transformed into friendship. He even thought seriously of setting himself up there to spend several months of the year at Biot. 'And then, Italy is not too far from here. And I should like very much to go to Italy every now and then, and see all those unseen treasures in the museums. Florence, Venice–there I could find my great friends Carpaccio and Bellini –what a feeling for space they had! And Piero della Francesca, that great silent aristocrat of painting–I could not forget him, nor the marvellous Cimabue, that solitary figure. He still stands out, even though Giotto has eclipsed his fame to some degree. His architectural design, his perfect sense of volume, the dryness of his handling–these are characteristics that make him a precursor; he can be seen as a pre-Cubist, just as Zurbaran was to be later. So far as the Italian Renaissance is concerned, of so many artists, only four or five were men of genius. The others show off, often they slavishly follow other artists' work, thinking in terms of their rich patrons. Their work is often pompous. When I went to Italy with Léonce Rosenberg I did not go to see Veronese, Titian, Tintoretto or Raphael. They are certainly great painters, but their work has no interest for me. The artists of the Middle Ages thought in aesthetic terms, and so did the Egyptians and the Etruscans . . . From the middle of the 15th century onwards there is almost nothing that attracts me . . . But, I repeat, Carpaccio and Bellini really stand out . . .' These were the sort of things Léger would say of Italy and of the painting of the past. He had indeed travelled to Italy in 1924 with the art dealer Rosenberg. Cimabue and the Primitives–he described them as 'pure'–seized his enthusiasm at that time.

Léger enjoyed very little of the sun and the land of Provence. On the 17th August, 1955, at Gif-sur-Yvette, he was struck down by his very energy and strength, still at the height of his creative powers. So died one of the most individual artists of all time; a man who had truly dared to break with pictorial tradition by painting re-created machines, faces and bodies whose features had been mechanised. The work he left is inimitable; it is revolutionary, but it approaches the purity of the Classical world in its refinement and technical excellence.

Our age, which Léger foreshadowed and for which he assumed responsibility in his easel paintings and mural works, has not yet grasped the full meaning of his work in its profundity. I would add that this is almost logical; for more than forty years Fernand Léger's art has been so far in advance of its time, broadening and even surpassing the bounds of painting, and has had such an impact, such an influence on our collective existence, that it sometimes appears to have been superseded by the work it stimulated in the first place, whether in the field of advertising, poster design, decorative panels, ornamentation or window dressing (free objects in space). Léger also succeeded in endowing the idea of machines and of mechanics in general with a stylistic form which our eyes can grasp and recognise; for instance: in a row of kitchen utensils hung on a wall, in a tractor that makes a flash of pure colour in the middle of a field, in a lorry carrying advertising on the streets, or in a chain of electricity pylons spanning fields and valleys along the horizon. We should not deduce from this that Léger was a 'decorative' painter. One must make a distinction between the play of form and pure colour used by the decorative painter, the shock provided by the object when isolated in space (the new reality created by Fernand Léger), and the wholly aesthetic value of Léger's creations.

Fernand Léger was primarily a painter, even though his work extended into other fields: ornamental work, scenery design, fresco, mosaic and stained glass.

Pursuit of form

As has been said, Fernand Léger was born in Normandy, at Argentan, in 1881. He inherited from his father, a cattle farmer and trader, an athletic physique, like that of a wrestler, a forceful countenance, and a speech which, mingled with the inflections of dialect, seemed that of a singer. After his father's death, his mother and uncle looked after the boy's education. From 1890 to 1896 he studied at the school in Argentan, after which he went to a monastery school. His father's dream had been for his son to be an architect. When he left school young Fernand spent three years as an apprentice to an architect in Caen. But then yielding suddenly to an inner impulse, he decided to become a painter, to his family's great displeasure.

In 1900 Léger came to Paris. He had to fend for himself to get ahead and to attend courses at various private academies. Once more, he worked for an architect. After his military service, he joined the Ecole des Arts Décoratifs in 1903. Further spells of work with an architect prompted him to complain later that architecture, with which he had wanted to have nothing to do at first, had pursued him throughout his life. He then found work retouching photographs. In 1906, 1907 and 1908 Léger's paintings were dominated by Impressionism. He spent a period of many months convalescing in Corsica. Some time after his return from Corsica, he destroyed the majority of the paintings he had worked on there. With some difficulty he sought to break away from Impressionism. The *Jardin de ma mère,* entirely Pl. 2
composed of strokes of light and colour which dissolve the forms, and the *Portrait de mon oncle,* in which the influences of Cézanne and at the same time of Ingres, are faintly discernible, are almost the only paintings which Pl. 1
survive from this early period.

In 1908 Léger set himself up at last in the La Ruche studios, in Montparnasse. Those who lived there or who were to come there included Delaunay, Chagall, Soutine, Lipchitz, Laurens and Archipenko. The last-

named entered into a friendship with Léger. A few years later he recalled these years of apprenticeship and his friendship. 'Archipenko too was a good friend . . . One day when we had not a penny to our names, with debts as well, we became strolling minstrels; he sang and played the harp, while I carried the instrument. We paraded through the whole of Paris, from Vaugirard to Belleville. Archipenko would sing in Russian. It was during this period that I began to know the people of the suburbs and to be aware of the first characteristics of my pictorial style.'

It was during this period that he met the poets Max Jacob, Apollinaire, Reverdy and Blaise Cendrars; they were to become lifelong friends.

His most important encounter with Cézanne's work dates from 1907, the year of the great Cézanne retrospective exhibition at the Salon d'Automne. 'Cézanne, the master of us all! Of all us moderns. I sometimes wonder what contemporary painting would have been without him. I have worked against the background of his painting for some time now. It was always with me, inexhaustible. Cézanne taught me to realise the importance of form and space, made me concentrate on drawing. I had the feeling then that the drawing should be dry and unsentimental', he was to write later.

From this period onwards drawing plays a cardinal role in Léger's work. This involved dispensing with the last remnants of Impressionism and returning to a precise handling. The fact that Léger became a great colourist makes us perhaps forget the essential place drawing had in his work throughout his life. He looks around him, studies closely, adopts even a realistic approach. 'I pursue form and I end up with rhythm.' Finally he reaches his interpretation, as envisaged: 'I always work from the object and have no truck with sentiment.'

Fig. 2

Les Nus dans la forêt of 1910 is the key work of Léger's new style, in which he takes up themes suggested by Cézanne's work, in direct contrast to his preceding, more lyrical phase. Cubism had already established itself by this time. In the new sense of space provided by the different perspective, some of the painted or drawn elements stand out or recede on the surface of the canvas or paper. Classic perspective is retained in the distance, providing a recession from the outer edge, employing various devices such as chiaroscuro, foreshortening and *trompe l'œil*. There is present in *Les Nus dans la forêt* a very basic, harsh and metallic rhythm. The machine age is already referred to in the shock produced by the polyhedrons and cylinders. A solid harmony emerges from the initially contrasting forms. How far we have moved from the charm of Impressionism! The trunks of the trees and the bodies of the figures end up with the same shapes in this study of form in nature. It was in this canvas that Léger achieved that dynamic force which fills his paintings, leaving no empty spaces because of the intensity of the interplay of volumes.

Later, thinking back to this period when he reacted against Impressionism, Léger would say in an almost apologetic tone, 'There had to be this struggle, this merciless eradication in my paintings. I felt that the era of lyricism was over. But one must admit that the Impressionists achieved a fantastic revolution. They put an end to chiaroscuro. What a marvellous play of colour, what brilliance! One should take one's hat off to Manet, that great master. One should not forget that his works form a transition between the 1830 school and Impressionism. This one must remember.'

Léger's Cubism was radically different from that of Braque, Picasso and Juan Gris. Léger moved around objects in a much more elementary and less intellectual fashion, finding great pleasure in clear-cut and simple forms, upon which he played a clear and limpid light. His very forthright nature disinclined from esoteric refinement and over-involved imagery.

A very red red and a very blue blue

La Femme en bleu, exhibited at the Paris Salon d'Automne of 1912, following *Les Fumeurs* in 1911, made quite a stir there. It represents a milestone in Léger's development, an expansion of the theme of *Les Nus dans la forêt*.

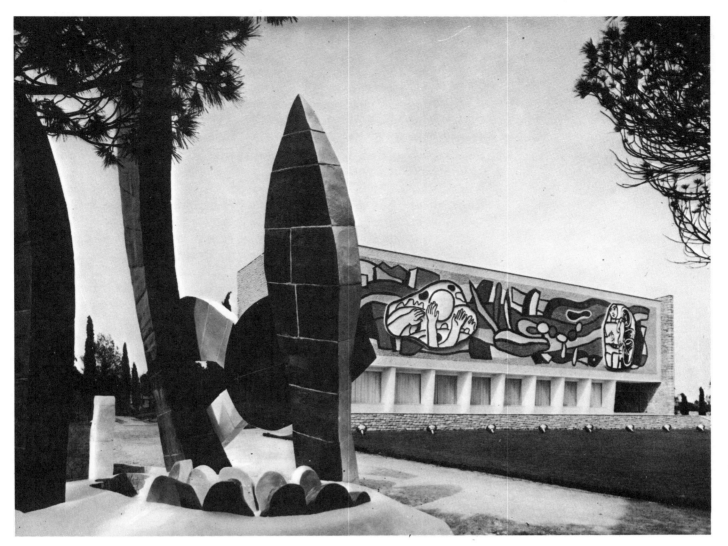

Here we find the artist on the threshold of the liberation of colour from its bounds in reality. The work channels the eye in a rigorously clear vision of forms and colours. The first elements of that rule of contrasts which govern all Léger's later work appear with convincing force. It is the first indication of the importance of local shading in the context of complementary colours. The forms are simplified and modelled. Circles and cylinders interrupted by flat planes establish the framework of the person represented in *La Femme en bleu*. The mass that is so contrasted has no need of the usual chiaroscuro to make itself evident on the surface. Objects, faces and bodies are no longer to be considered in conventional pictorial terms, but in the context of their essential content, so excluding all sentiment, the forms are linked together through an interpretation which at once breaks them down and at the same time reorganises them in geometrical forms.

The dynamism is enhanced in the *Contrastes de formes,* 1913, through the sense of mass, which represents an extension of the same feature in *Les Nus dans la forêt*. All references to recognisable forms have disappeared. The abstract forms have acquired a new energy, and their natural rhythm suggests a mechanically articulated world such as we find in the *Village dans la forêt*.

Another feature which sets Fernand Léger apart from the other Cubists is colour. It is true that Robert Delaunay tended towards polychromy, but Picasso, Braque and Gris had moved towards monochrome painting in their Cubist works. 'Then there was the argument with Delaunay himself', Léger said later. 'He continued the Impressionist tradition of juxtaposing complementary colours, red against green. I did not want to use two complementary colours together any more. I wanted to isolate the colours, to produce a very red red, and a very blue blue. If one places a yellow

1 The Léger museum at Biot

Pl. 3

Pl. 4

next to a blue, one immediately produces a complementary colour, green. Delaunay was moving in the direction of the modification of colour, while I strove to achieve clarity of colour and of mass and contrast. Pure blue remains pure blue if you place it next to grey or a non-complementary colour. If you set an orange against it, the relationship may be constructive in formal terms but it does not enhance the colour.'

Nevertheless what Delaunay's and Léger's paintings share is movement and the love of life which permeates them. This sense of movement is present also in the work of Marcel Duchamp during the same period, and in that of the Italian Futurists.

Pl. 5

In the *14 Juillet* of 1913 Léger adopts a popular theme, whose formal potential he immediately achieves. The rectilinear vertical lines contrast with the mass implied by the curves which recede in a frontal perspective. Even though it is two-dimensional, this canvas gives a strong impression of depth. This effect is achieved by the juxtaposition of intersecting planes. The white, red and blue of the French national colours blare out like a fanfare. The formal beauty of the subject exists here independent of any sentimental, descriptive or imitative values. Naturalism is placed beyond the pale. Fernand Léger subsequently elaborates further this 'framework' of his pictorial conception. The figures and all that surrounds them tend to be regarded even more as a world of objects with a precise role to play in a defined space. Consequently their new image acquires a deliberate quality of 'tension'. It takes on an absolute value, independent of what it represents. The intensity which emanates from the painting is identical with that of the industrial age which discards and rejects with brutal frankness anything intellectually esoteric or pictorially intimate. Léger wrote explaining his work to the public. 'When I had achieved the sense of mass that I wanted, I began to arrange the colours. But how difficult it was! How many canvases I destroyed . . . I would have liked to see them again now . . . I was very conscious of colour, and I wanted to imbue my masses with it. A work of art must have meaning in its time, like any other intellectual work. Since painting is a visual expression, it must necessarily be a reflection of external conditions rather than psychological ones. Every painting must have this momentary and yet permanent quality which constitutes its value beyond the time in which it was created. If the manner of pictorial expression has changed, this is because modern life has necessitated such a change. That which is imagined stays less still, less is seen of the object itself. A landscape that is crossed and interrupted by a car or an express train loses some of its descriptive quality but gains a synthetic value. The carriage windows and the windscreen of the car together with the speed achieved, have changed the accepted appearance of things. Modern man registers a hundred times more impressions than an artist of the 18th century. This may be illustrated, for instance, by the extent to which our language has been expanded through diminutives and abbreviations. The condensation involved in a modern work of art, its variety, its rhythm of forms, results from all this. It is certain that the development of channels of communication and their speed have an impact and a place in our visual experience. It is facile to suggest that all this is anarchy, simply because the whole development of the speed of modern life that is represented in modern painting is not immediately apparent. One tends to think of a sudden break in historical continuity, but the fact is that painting has never before been so realistic and so linked to its time as now. Painting is beginning to be dominated by the most elevated form of realism, and it will be a long time before it stops.'

In 1914 Léger was mobilised and sent to the front. The experience of war profoundly affected the artist and changed the direction of his art.

In his moments of greatest stress, he became aware of the beauty of those cast-iron and steel monsters, he marvelled at the mechanical precision of gun breeches and at the impeccable shape of their barrels. He was fascinated by the automation of the tanks, just as if these vehicles were strange beings from another planet. Even through the bombing and the artillery fire he

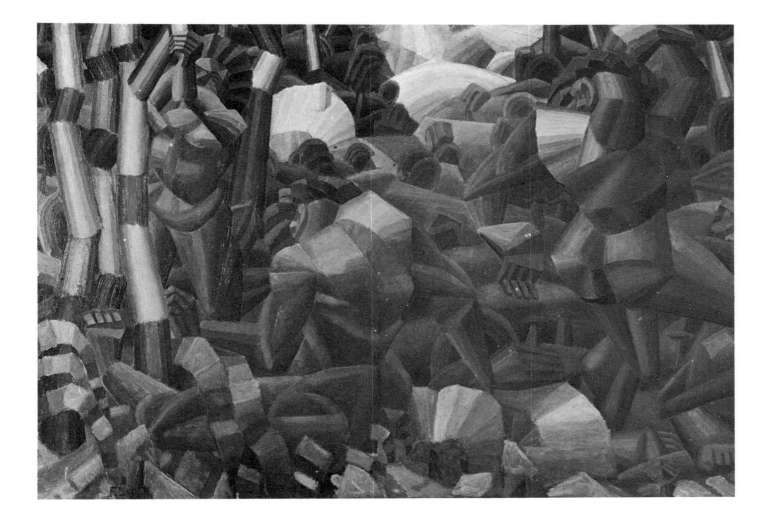

2 *Les Nus dans la forêt*
1910, oil on canvas
Rijksmuseum Kröller–Müller,
Otterlo

was still aware of people. 'I land here from an intellectual environment—
that of Apollinaire, Max Jacob, my friends, all the others—to find myself
amidst peasants, navvies, miners, boatmen. But I find myself at one with
them, and one of them. Their free speech, their dialect are my language. I
have wanted my work as a painter and the images which I produce to be
as well founded as that dialect, to have the same directness and honest
cleanliness. I have lived for four years alongside that energy and I have
experienced the feeling of fraternal solidity. I have made dozens and dozens
of drawings. I have felt the body of the metal and my eye has seen the
geometry of shapes. It was there in the trenches that I arrived at the objective.
I thought again of my first abstract studies, and a wholly new conception
of the form, use and purpose of abstract art came to me.'

Soldat à la Pipe, 1916, *Soldats jouant aux cartes,* 1917, and *Le Blessé,* 1917 Figs. 7, 8
are works which are inspired directly by the world of the trenches. In
them there is no story, just objective forms. These objective forms are so
forceful that the spectator is aware of their premonitory character, of the
cruel events to come. The lack of expression does not impede the pointings
of the finger of accusation. This is the implacable voice of a new poetry.

These three paintings are three masterpieces, which reveal an artist in
full command of his medium. Gassed but recuperated, Fernand Léger uses
a more explicit figuration; his figures are imprisoned in a mechanical
framework whose forms possess a hallucinatory quality, as if the deadly
instruments of war continue to dominate men's actions, turning them into
robots.

This is also the period of the first appearance in Léger's work of printed
type characters and letters from posters, as in *Le Typographe,* 1919, an
imaginary figurative composition. The characters are not intended to be
decorative, nor are they surrealist in tone, but they do have a precise role
to play in the context of the composition as a whole. If we take the extra-

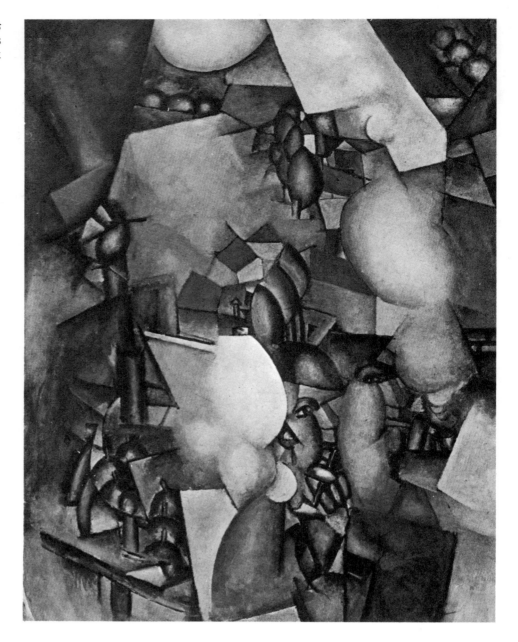

3 Les Fumeurs
1911, oil on canvas
Guggenheim Museum, New York

ordinary *Soldats jouant aux cartes,* we find that the decorative elements,
the pipes and the playing cards, have a specific figurative role to play as
elements of contrast in the composition as a whole. From now on all
elements in Léger's paintings have a precise role to play.

1918. Léger exclaims, 'Peace! Man, worn out and having lost his identity
in four long years of suffering, raises his head, opens his eyes and stretches
himself; he takes pleasure in life anew, feels the frenzy of being able to dance,
spend, at last to stand upright, and shout, and squander. A whole wave of
energy is released throughout the world. The canary and the red flower
are still there, but out of sight. Through the window the bright colours of
the wall opposite hit one in the face. Huge letters twelve feet high invade
one's flat. Colour takes a new place and dominates day-to-day life. One
must adapt oneself. The human being of 1921, though restored to normal
life, retains the moral and physical tension of the hard years of the war.
The exchange of letters has now replaced the exchange of gunfire. Indus-
trialists and traders brandish colour as a weapon of publicity against each
other. A multicoloured vision of unprecedented corruption batters one's
sight. There is no rein, no limit to this onslaught which hits one's retina,
blinding and driving one mad; whither next?'

Man-machine As soon as peace was re-established, Léger unhesitatingly set about the task
which he had set himself: to be aware of his own time in order to translate

its industrial civilisation into a visual, almost rhythmical framework. What then is the main line of his pursuit? To provide a definitive synthesis between the diverse forms of three-dimensional art, that of engineering and the philosophy of a materialist harmony. Here I think that I may without repeating myself, go back to a passage which I wrote in my book *Léger ou le dynamisme pictural,* published by Cailler. I feel I may allow myself to quote from it, for when I read it to Léger before it was published, he as my teacher and friend approved it unconditionally and supported my critical interpretation: 'So Fernand Léger may appear to have emerged directly from *L'Homme-Machine* by the encyclopedist La Mettrie. For the latter man is in fact a function. A function understood in the sense of a mechanism, like an organ which is an element of material function independent of divine intervention. So Léger inscribes the imaginable facts of nature on his mechanical counter. The universe in which he exists is a sociological one. Nothing in his compositions is either 'real' or 'abstract'. Everything has this common sociological function, everything becomes 'functional'. The forms which emerge will stem from an organic urge;

4 *La Femme en bleu*
1912, oil on canvas
Kunstmuseum, Basle

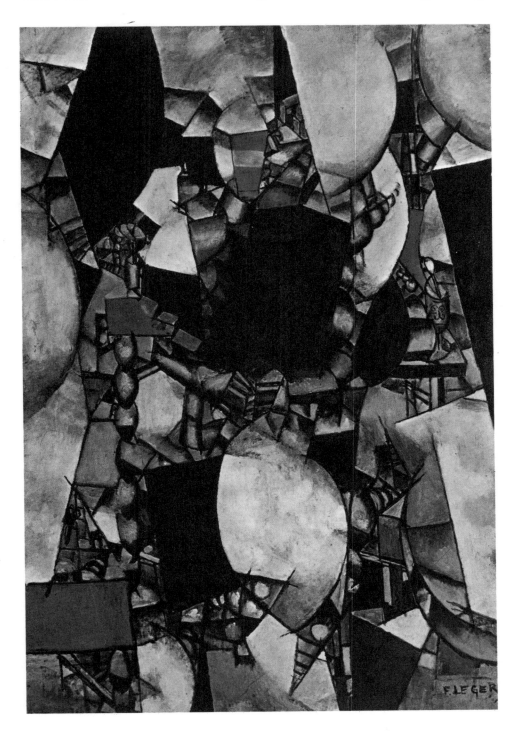

5 *Modèle nu dans l'atelier*
1912, oil on canvas
Guggenheim Museum, New York

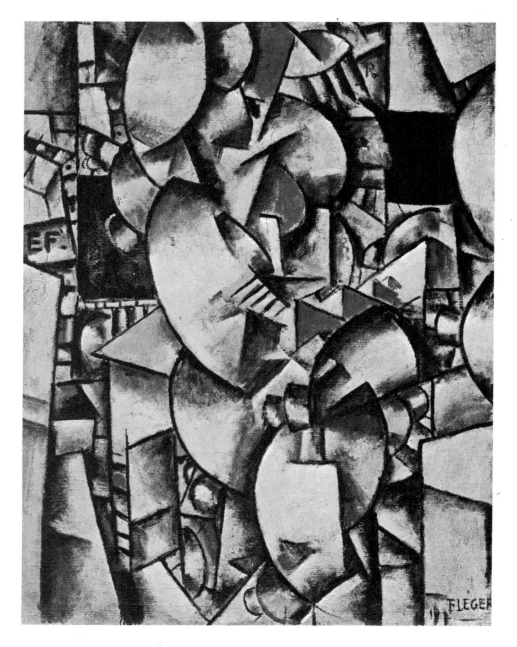

they may combine human references with the most diverse forms, and Léger's principal aim is to endow them with stylistic consistency, in which the impassivity of the artist is essentially the calm triumph of the creator over the nature which surrounds us.

'Just as in the mind of the painter a house or a machine are tangible objects before they assume the character or architecture, so the human body is a functional entity, endowed with energy, before being a man. Let us take notice of these functional elements, these machine parts—tubes, cylinders, pistons, pulleys, rods, gears, plates, etc; let us observe their arrangement, their profile, their mounting; we cannot but be struck by their relationship with the organs of the human body. This juxtaposition of elements is valid for some botanical items too—the organic growth implicit in a leaf which will become a tree just as an eye or a nose will become a body—Nature-Machine, Man-Machine . . . But thought itself has weight and impact. Man dominates and transforms. He measures according to his own laws, expands the world. There was in antiquity a god who in pursuit of a nymph, transformed her into a laurel. Today modern man, shunning gods and legends, sets the nymph of the imagination free, rendering the laurel more beautiful than it is in reality, just as if it contained a part of his active conscience. Man can progress if he remains in command of his discoveries. Fernand Léger is aware of this as he paints a machine flat on a canvas, revealing at the same time the depth of this perspective. Léger's painting

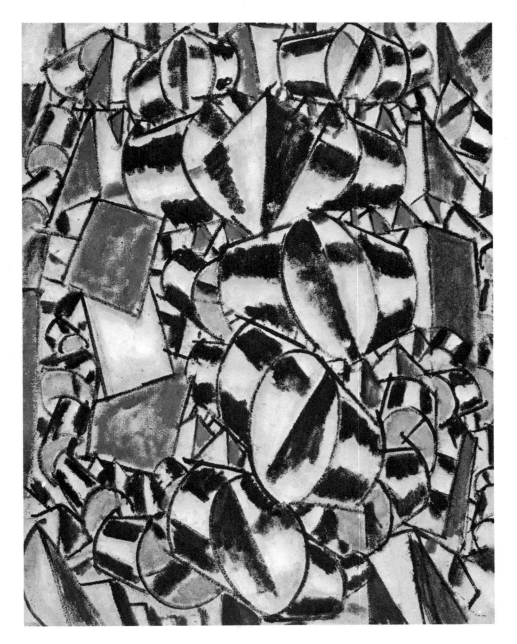

6 *Contrastes de formes*
1913, oil on canvas
Museum of Art, Philadelphia

takes on an active *raison d'être*.'

This is the beginning of his mechanical period. Léger does not imitate or copy machines, he invents them. His eye scans motors, turbines, dynamos, drive belts, gears and bolts, grasping the essence of things and presenting a unified vision of the whole.

The precision of Léger's handling becomes more and more definite. The picture plane is traversed by broad lines, freeing the composition of any modelling. The means of expression are wholly scientific, and what dominates the composition is its geometrical severity. At the same time, the canvas also miraculously retains the freshness of enthusiasm, the touching simplicity that might be that of the Primitives or of the Douanier Rousseau (for whom Léger expressed deep admiration). The object becomes disproportionately large; it is the world of the immediate foreground that hits the eye here. The relationship between the various elements is founded on startling and sometimes violent contrasts: the constructional basis of the new reality which Léger establishes is founded on the growth of a controlled organic flow, channelled by means of the tools of his creativity which are at once those of an artist and a craftsman. It might appear that all the paintings of this 'mechanical' phase had been worked on by some master-craftsman who had perfect command of the art of welding, of the points of stress and resistance of metals, of their strength and flexibility, of the forces of rotation and centrifugal motion. *Les Eléments mécaniques,* 1918,

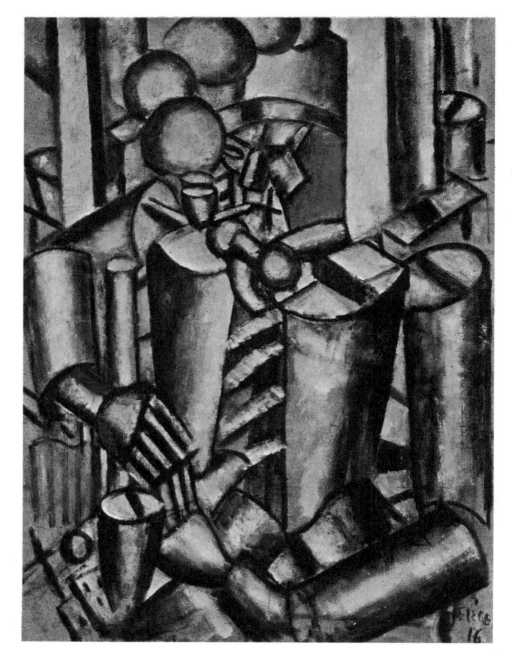

7 *Soldat à la pipe*
1916 oil on canvas
Tokutaro Yamamura Collection,
Japan

Fig. 9 *Les Acrobates dans le cirque*, 1918, *L'Homme à la roue*, 1918, *Le Remorqueur*, 1918, *Le Chauffeur nègre*, *Les Disques*, 1918, *La Ville*, 1919–all these paintings show how decisive was the direction which Léger's painting had taken. *La Ville* may be regarded as a work representative of the period. It implies a revolution in three-dimensional representation. He was now able to achieve depth and dynamism without chiaroscuro, without modelling. *La Ville* provided the foundation for the art of the industrial poster. The titles of Léger's paintings manifest their source of inspiration in the plebian and industrial environment of the urban centre. His pictorial-mechanical creations celebrate the beauty of the models which inspired them. His vision reveals to us the practical meaning of this beauty! No artist before him had dared to take such a step, nor had any reached such a degree of control over an environment that had hitherto been regarded as vulgar. To Léger, manufactured objects are equal in beauty to the finest still-lifes, the most exquisite portraits of conventional painting. The human figure itself appears as a further reflection of the age–acrobats, workers, drivers and helmsmen are set against the mechanical background, their own features being mechanical and depersonalised.

Painting and architecture After such a period of concentrated activity, Léger felt the need to relax. This is evident in the works of the following period, whose monumental

figures are set firmly in compositions that are less charged with violence.
The pace slackens, the impression of a single dimension increases, more
attention is paid to detail. Léger was later to write, 'I had broken the human
form, then I set to reconstructing it, finding its true image again.' Now he
employed the human figure in a more realistic and less schematic form, as
in *Femmes au bouquet*, 1921. There is something solemn about this com-
position, which marks the return of such subject-matter. It contains a serene,
tranquil grandeur, that has echoes in the ritual simplicity of primitive art.
It seems to present an enigma, raising a silent query against a background
of motionless space. There remains an element of tension in the background,
but it plays a secondary role. Time is suspended, one's breath seems to be
held in anticipation of an event. The figures are frozen in a hieratic and
centennial stillness. The representation becomes considerably more realistic
around the faces. The figures reclining in the middle-ground of the painting
assumes gigantic proportions. The hair shines with reflections, like a metal
strip. Even though Léger does make use of modelling here, it has nothing
to do with chiaroscuro, with light and shade. Despite the artist's opposition
to the 'individual', these paintings are often intensely fascinating in them-
selves. The spectator inevitably finds a kinship with these 'primitive'
statues. *Le Mécanicien*, 1921, *Le grand Déjeuner*, 1921, *La Tasse de thé*, 1921,
La Femme au vase, 1924, and *Le grand Remorqueur*, 1923, are among the most
notable paintings of this 'static' phase.

Pl. 6

 Le grand Remorqueur, 1923, has a marvellous geometrical precision, and
perfect correlationship of abstract with figurative elements and levels. The
town and the tug are brought on to the same plane but one has nevertheless
a strong impression of perspective depth. The impression of the town—a
contemporary one—shows that Léger was a visionary, who foreshadowed
modern suburban architecture. Indeed architecture pursued Léger through-
out his career. His friendship with Le Corbusier dates from as early as 1920,
and their collaboration was an active one. Together with the architect,
Léger investigated the problem of abstraction and the wall panel in archi-
tecture. He resolved the problem thus: 'Abstraction? It represents a libera-

Pl. 7

8 *Soldats jouant aux cartes*
1917, oil on canvas
Rijksmuseum Kröller-Müller,
Otterlo

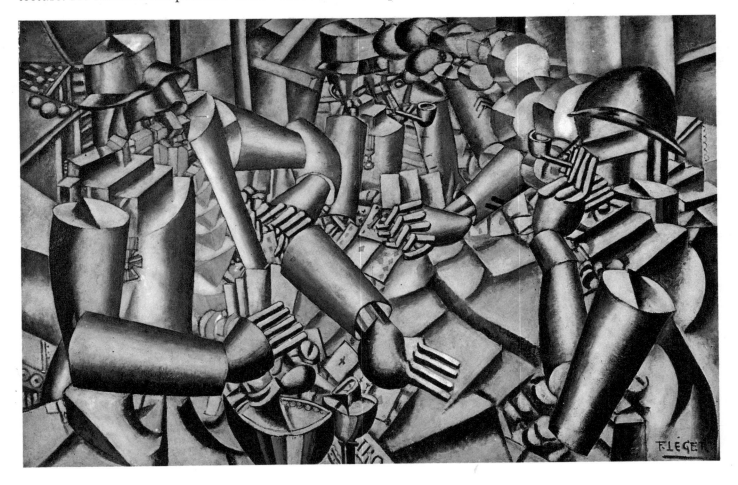

9 *La Ville*
1919, oil on canvas
Museum of Art, Philadelphia

tion, an inevitable step in modern art. We start again from scratch. It is not for me a goal on its own, an end in itself, it is simply a means of clarification, a starting point for new conquests and achievements. I was not affected by Purism: it was too dry for me, although it was an indispensable factor. There are kinds of painting that are open and others that are closed. Renoir, for instance, is a closed painter, while Cézanne is an open one. He is always moving towards new things. On the whole, pure colours and geometric shapes are not sufficient for the easel painting; abstraction demands vast surfaces, walls, which provide the possibility of structure and rhythm. This is the 'architectonic'. Nevertheless I would add that easel painting frequently has its limitations. Mural painting on the other hand has no dimensions. They are two different fields. My first mural paintings were created for Le Corbusier. They blended well with the architecture in a rhythm of contrast of distinct colours, decorative function, expansion of space, need for luminosity.'

We have spoken of the *raison d'être* of Léger's art. Whether it is figurative or abstract, it has above all the function of ordering and setting in motion Fig. 14 a complex organism of shapes and colours. Thus in *La Gare,* 1922, and *La Nature morte dans la cuisine,* 1922, abstract planes and recognisable features clash and contrast without either dominating the composition. The result is a powerful three-dimensional effect about which it is irrelevant to think in abstract or figurative terms, because there is no ambiguity.

Pl. 8 *Le Triangle jaune,* 1924. Here the features are wholly abstract. The roundness and the curve are in contrast with the angularity and the straight lines. The principle of contrast dominates the composition. It is a severely architectonic composition. Every element has a place in relation to all the other elements.

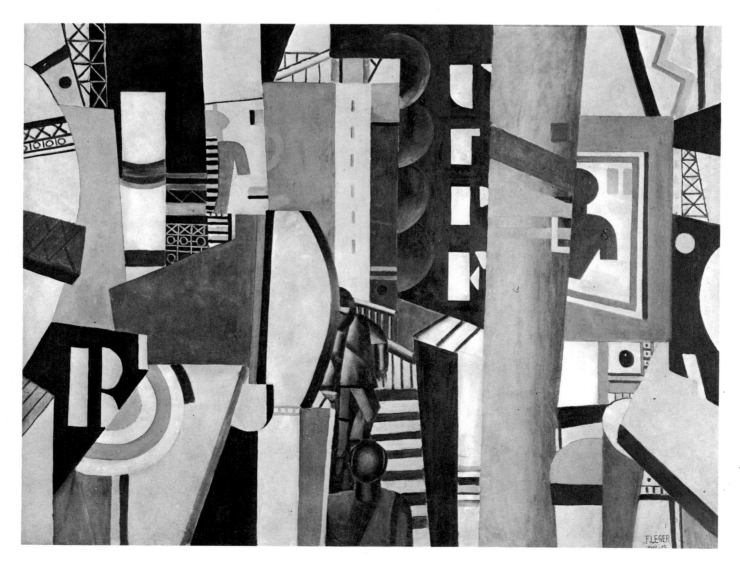

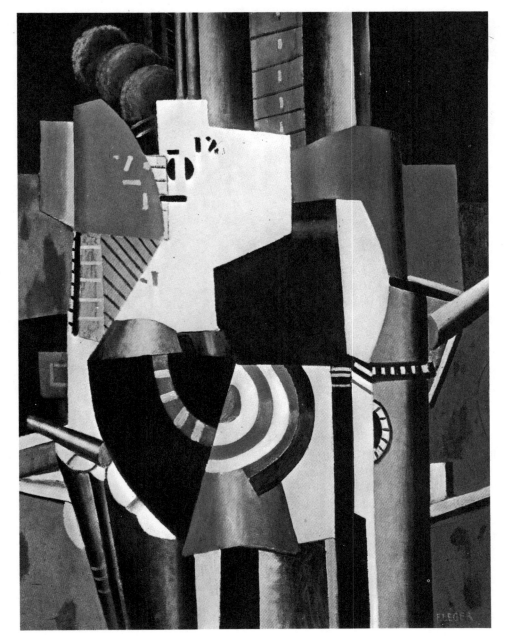

10 *La Ville*
1919, oil on canvas
Museum of Art, Philadelphia

In 1921–2 Léger had designed the scenery and the costumes for the *Skating Rink* of the Swedish Ballet. In 1924 he collaborated on a short film with Man Ray and Murphy. The subject of the film is an object, that is to say, an object and its component parts, treated in close-up. This film, *Ballet mécanique,* enchanted the Russian director Eisenstein, who wrote a letter of congratulations to the painter. The film, which demonstrates the value of an object in itself, in movement as well as when static, continues to have a considerable power of attraction for cinemagoers whenever it is shown. Léger's participation in the *Ballet mécanique* had an impact on his painted work, which became less 'static' and monumental. His interest becomes focused on objects or their parts, set in a space that results from a new optical approach. Léger described this moment in these words: 'It is not the beauty of the thing which one is painting that matters, but rather the means which one adopts to re-create the object even if it is only a nail. This nail must retain its dignity as an object. A painted nail should have the same importance as a face. I have scattered my objects in space and I have so arranged it that they all balance each other, making them stand out against the surface of the canvas. It is all a play of harmonies and rhythms based on background colours and surface lines, distances and contrasts.' And further, 'Today the work of art must be able to stand comparison with any manufactured article.' Fernand Léger endows objects with the greatest

Objects in space

23

possible density. Some objects are contrasted with others, or else with invented forms which possess the same density. It is a play that is at times static, at others dynamic.

This period characterised by objects in space was a prolific one. He produced canvases at a rapid rate once the experience had been translated into work. If we look for instance at the *Composition à la feuille,* 1927, we will realise that our attention is not directed towards either one of the elements especially, but rather their effect together. No element is allowed to dominate, although each maintains its independence, set in space without perspective or other support. There exists in this painting a new realism in the method of considering objects, in which the objects themselves are given primary emphasis. The visually recognisable objects are a leaf, a branch, scales and weights, a decorative (semi-abstract) panel, a perforated rectangle, geometrical planes. These heterogeneous elements are reconciled and contribute to an internal rhythm precisely on account of their contrast. Their arrangement contributes to the evaluation and to their severe balance in a space that is 'outside the atmosphere'. The manner of treating the surface is vertical, but there is an immediate impression of a minimal frontal perspective that conveys an imperceptible depth of field through the play of contrast in the background and the transverse elements, whose placing is alternately forward and backward. Colour is used liberally and is an integral part of the design. The same comments could also be applied to *Le Profil noir* in which, however, the optical illusion is more limpid and airy. Hence once again the relationship of the objects contributes to, step by step and almost paradoxically, the creation of a magical impression. Léger's excursions into the world of objects in space does not, however, prevent him from returning now and then to the architectonic style, to the monumentality of the 'static' period, in which the human figure, endowed with metallic hair, stands out, appearing at times impersonal and disturbing, inexpressive, mysterious and primitive, and at others barbarous, full of hieratic nobility and majesty. Such are the *Deux Femmes,* 1929, *Deux Figures,*
1929, *Deux Sœurs,* 1935, *Deux Femmes au vase bleu,* 1935, which are stylistically no less impressive than the *Composition aux trois figures,* in which the figures are set in space with the same simplicity and natural candour as the objects in the background. These compositions were painted during the same period as others that also belong to the series objects in space, and still others whose subject-matter is purely abstract.

During this period it seems that a particular element engaged and caught Léger's attention: the key form. This latter was to continue to inspire his imagination, and to become a concrete element in his anti-metaphysical style. It indubitably also constitutes a subconscious although positive symbol of an open sesame in the mind of the artist as creator.

Léger's paintings of the *Composition au parapluie et aux clés,* 1928, the *Composition aux clés,* 1928, and *La Femme aux clés,* 1930, will, despite their perfect execution, come second in the estimation of anyone who is aware of modern painting, to the memory of the famous *La Joconde auxclés,* which had the impact of a bombshell in some quarters. Nevertheless, Léger's inspiration in this painting is no more than the projection of three-dimensionality. One can certainly detect a trace of Surrealism, an echo of the contemporary cultural climate. But Léger is seeking here to make an arresting juxtaposition between commonplace forms, in this instance those of keys, and a human figure, that of the *Mona Lisa*. His choice of the universally recognisable Leonardo painting is motivated by a desire to enhance his vision of three-dimensional form in its appreciation by the public and his critics, even to the extent of provoking a scandal. By now, through the passage of time, *La Joconde auxclés* has itself joined the ranks of the classic masterpieces of painting.

The great subject compositions

After a stay of two months in the United States in 1931 Léger, on his return to France, set seriously to thinking about the possibility of a renewal of

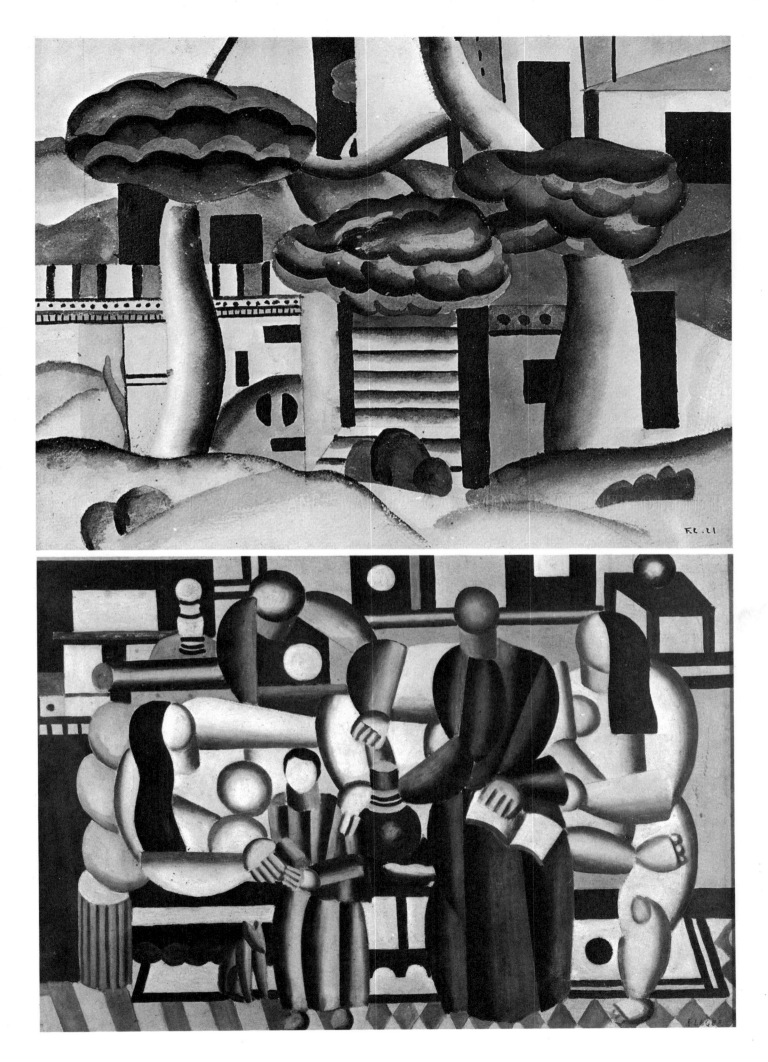

13 *Femmes dans un intérieur*
1922, oil on canvas
Musée d'Art Moderne, Paris

painting, just as he had been so inspired in 1924 following his visit to Ravenna; faced with the spectacular mosaics in the Byzantine churches he had been prompted to think in terms of 'mural' work.

What characterises the years 1933–5 is above all the freedom in the employment of colour and the experimentation with more and more deliberate abstract forms, foreshadowing those which were soon to make up the great subject compositions. During this period Léger invented a recognisable vocabulary of forms and lines that became characteristic of his work, and recurred quite frequently as his work developed. For some

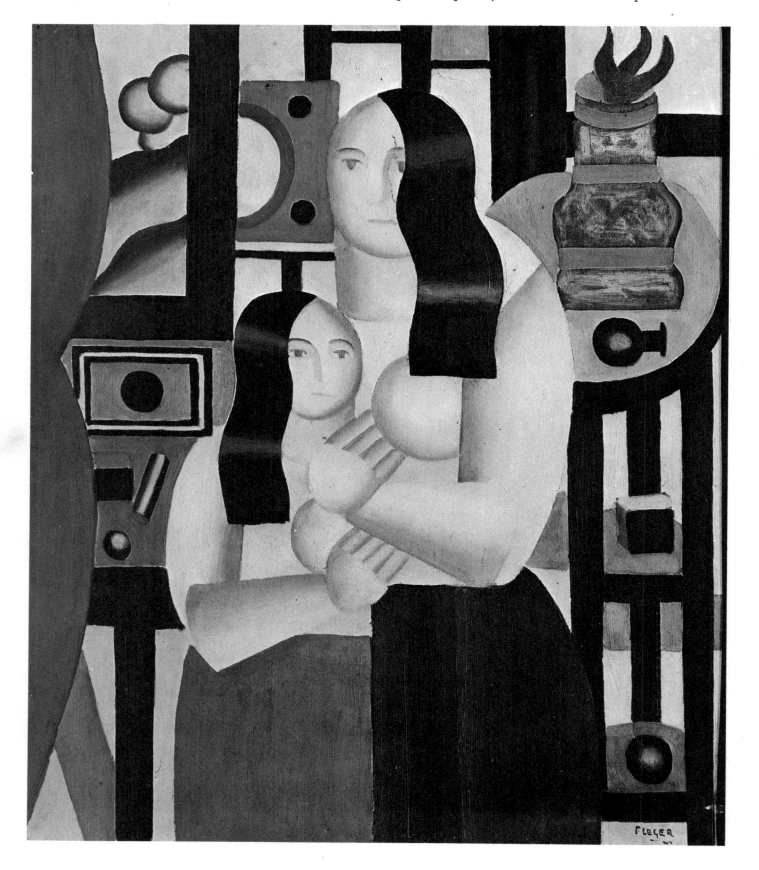

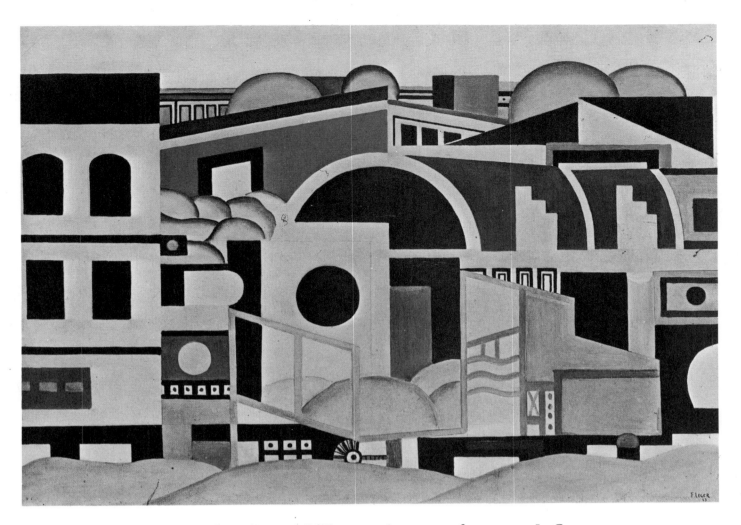

years he had been obsessed with an almost childlike attraction to root forms, tree trunks, birds, butterflies, and clouds. As a result, his paintings gained through his observation of life in action. In 1932 for instance, he recorded impressions of rural life on his farm in Normandy. He was particularly fascinated by cows. This led to a series of gouache drawings whose powerful oblique strokes suggested the slow and heavy movement of those animals. But in spite of this observation of reality, naturalism never predominates in his paintings over three-dimensional values. This is also the case in *La Feuille de houx*, 1930, which appears to be almost a painted sculpture, so strong is the impression of relief. It appears to be a hammered metal leaf, full of tears and welds and bruised points. Another organic element lies behind the inspiration of the *Queue de comète*, 1930, a panel from a screen. This unusual painting must be the fruit of an interruption in Léger's course of development, a moment of anti-geometrical relaxation, foreign as it is to his other work by reason of its almost sensual and surreal character.

Now we reach the innovatory period of the great subject compositions. These were in fact reached in stages and are foreshadowed in earlier paintings. *Les Musiciens*, 1930, a painting that is a drawing on canvas in its purity of outline and severity of structure, is dominated by Léger's graphic confidence. *Marie l'acrobate,* 1934, and *Adam et Eve,* first state, 1934, are equally significant works. Following his rule, he juxtaposes opposing elements in them. Figures are set against semi-abstract forms that are taken from reality and transformed into symbols, like those which were suggested by the form of clouds but which are associated, with no explanation, with others hanging on the transverse bars like bunches of felt.

Fernand Léger explained: 'I am tackling the subject on a large scale, but I repeat, my painting is still object-painting. It begins with Adam and Eve. My figures continue to become more human but I remain materially three-dimensional; no rhetoric, no sentimentality. The great subject compositions continued again, some years later, on the quayside at Marseilles. Some young

14 *La Gare*
1922, oil on canvas
Galerie Louis Carré, Paris

Pl. 12

Pl. 13

Pl. 14

Pl. 16
Pl. 17

dockers were bathing in the water. I was immediately taken by the trajectory which their bronzed bodies made as they leapt into the water. It was a marvellous, fluid motion. These divers took my attention away from everything else; the acrobats, cyclists and musicians became lighter and more relaxed.'

Concrete relationships between things

Léger thus embarked on the painting of large compositions, whose execution lasted some time: some of the pictures took as much as four years to complete, as with the *Composition aux deux perroquets,* 1935–8. From 1934 to 1935 onwards his work falls into two categories: on the one hand there are the semi-abstract compositions incorporating recognisable characteristics, full of vital energy, and on the other there are the great figure-compositions. It was also at this time that his talents as an imaginative scenery designer and outstanding mural decorator emerged. He was commissioned to produce a vast mural for the International Exhibition in Paris in 1937, *Le Transport des forces,* located in the Palais de la Découverte. The theme of this mural celebrated the discovery of electricity, a discovery that is expressed in the form of a grandiose symbol of universal significance. In 1937 he designed the scenery for *David triomphant,* with choreography by Serge Lifar, music by Mussourgsky and Debussy and direction by Vittorio Rieti. He was also commissioned in 1939 to produce the stage design for a work by Jean Richard Bloch, *Naissance d'une cité,* with music

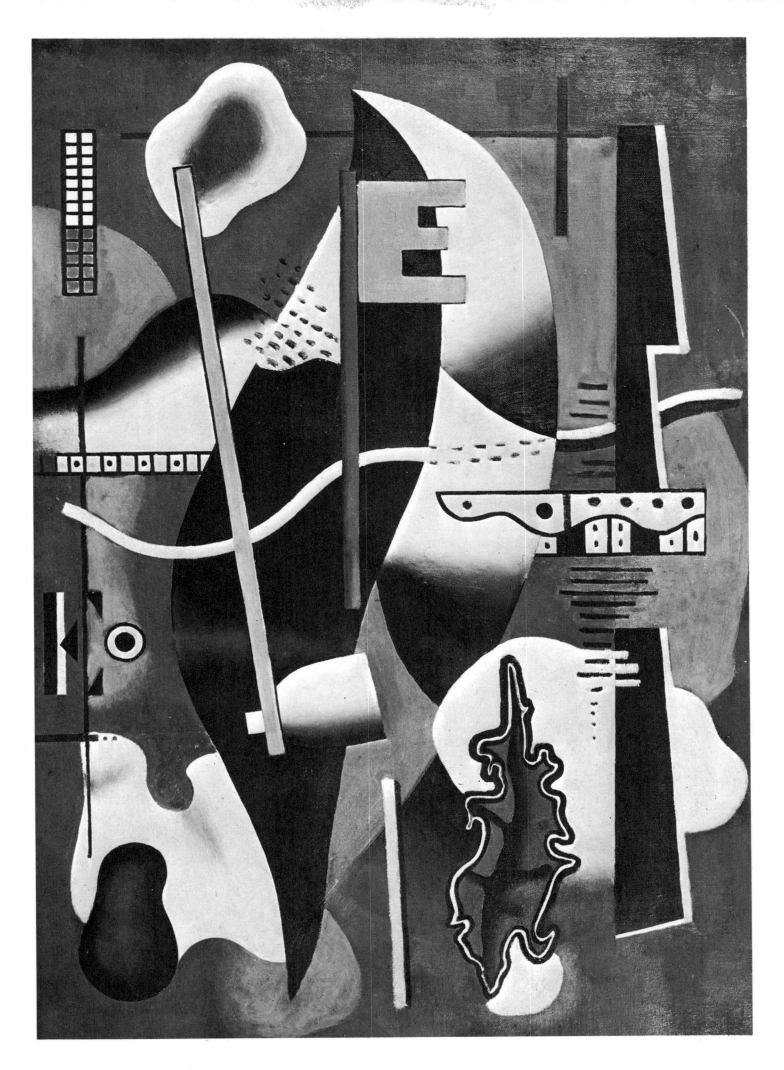

17 *La Figure à la fleur*
1930, drawing
Musée Léger, Biot

by Darius Milhaud and Arthur Honegger. In these productions he returned to the bold colouring and exciting effects he had used at the time of his participation in the Swedish ballets, in the scenery and costumes for the *Skating rink* and the *Création du Monde,* which had been in fact respectively for Honegger and Milhaud. By temperament close to the industrial worker, Léger readily took to these tasks in which he could freely express his anti-conventional ideas in the animated excitement of an entertainment. He was indeed truly familiar with the way to reach the heart and imagination of a wider public by echoing the nobility of objects, what one might call the heroic element, by the bold illusion of three-dimensionality, always devoid of sentimentality and continually reinforced by the principle of striking contrast.

At the same time Fernand Léger began to paint landscapes and became infatuated with the country. His palette reveals the pure poetry of forms and colours, and there is something fresh and musical in it which corresponds in its strength and tenderness to the natural rhythms of the country-side. The poetry of this moment is best illustrated in the masterpiece called *Papillon et fleurs,* 1937. The butterfly is endowed with the appearance of a lively object with four petals gliding through the leaves and aloes above a rounded form. Everything seems to vibrate, as if it were the first day of Creation. An impression of joy radiates from the vast painting, as it were from an invisible universal heart.

Soon the foliage in these paintings becomes the setting for birds, human beings whose colours are iridescent and give the impression of the sound of bells. These beings seem to be of the nature of colour itself, representing its joy and levity, colour that determines form and the character of life. This Léger's profound and benign happiness at the artistic harmony he achieves, thoroughly in tune with his own confidence; in spite of his lifelong struggle to establish a strong and courageous style in the face of dealers, patrons and art critics—a style that was the very antithesis of sentiment and was consistently a mirror of its time. He is aware that the truth and the essence of his art lie in concrete relationships between things, that these relationships are complex and that for his work to maintain its vitality, they must be continually questioned. Only in this way could he maintain the complete liberation of form, space and colour that renders a painting for instance like *Composition à l'étoile sur fond bleu,* 1937, not abstract to the extent that we will not at first glance seek to discover the secret relationship of the imagined forms with nature, the 'cadence' of real and imaginary things that are intimately connected, things which colour brings into focus like an elixir of long life.

Pl. 18

Painting beyond drawing

In 1938 Fernand Léger went to the United States for the third time. Nelson A. Rockefeller asked him to decorate his apartment in New York, and Léger accepted. He met up with old friends, the critic Sweeney, the writer Don Passos, the sculptor Calder and the architect Harrison. He also came up against the broader scope of urban design, bold design and daring construction, and the speed and pressure of life—an almost brutal human choice that presented itself to him. One should add that in the United States, as in countries in northern Europe, his work had been recognised and appreciated more than in France. The retrospective exhibitions which the Museum of Modern Art in New York and the Art Institute in Chicago had arranged in 1935 had been acclaimed as a triumph even by the American avant-garde. The most important and selective collectors prided themselves on the paintings they owned signed by Fernand Léger. So far as official recognition was concerned France lagged far behind.

On his return from the United States Fernand Léger hardly thought that he would return there in October 1940 as an immigrant. Caught unawares by the war and not wishing, as a well-known anti-Fascist who was on the Nazi black list, to fall into the hands of Hitler's troops, he fled first to Normandy and then sailed from Marseilles. But he took with him the memory

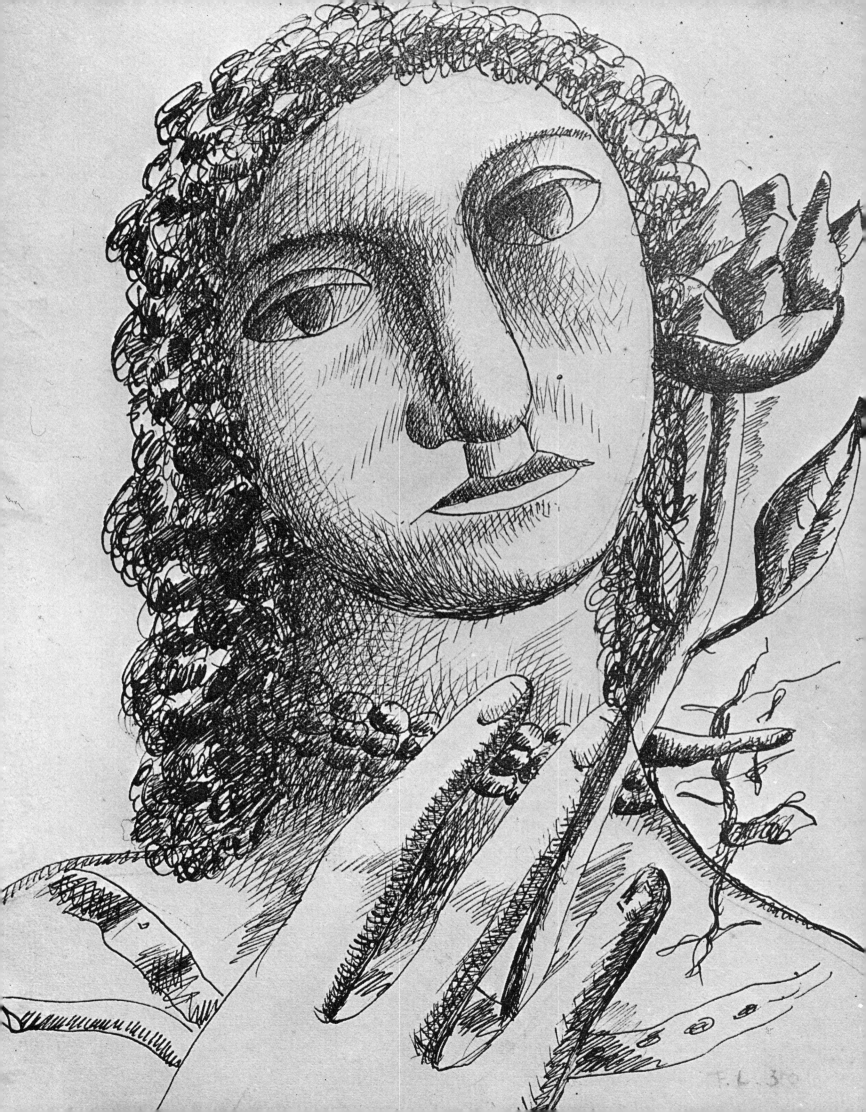

of the divers in the sunlight—those which caught his eye as he walked slowly along the Marseilles shores. He was to devote three years of his stay in the United States to them.

Pl. 19 The theme of *Les Acrobates,* 1942–4, developed alongside that of *Les Plongeurs.* They share the same architectonic interpretation of the painting, their rhythm is similar and their dynamism is of a like intensity. This is the Léger of the epic mural designs, which recall the early frescoes, the majestic compositions of remotest antiquity. The artist succeeds, in presenting a monumental effect that is nevertheless founded—despite the apparent immobility of the forms—on an obscure vital force that causes it to vibrate with a general movement, immobilised at the very peak of its muscular expansion. Herein lies the genius and the secret of the painter. The same
Pl. 20 comments may also be applied to *Les Plongeurs,* 1942–6, in which colour (*Les Acrobates* are painted almost in monochrome) accentuates the dynamism of the violent whirlpool with its disconnected human limbs. As in many of the preceding paintings the modelling lacks chiaroscuro (thus avoiding sentimentality), but despite the frontal approach, the painting has a profound and vibrant 'relief' which accentuates the depth of the field, implying a sense of mass in a space that has become an imperceptible perspective: the 'space-perspective'.

Comparison has been made between the linear handling of *Les Acrobates* and *Les Plongeurs,* in its sureness and confident evolution, and the drawings of Michelangelo. This comparison is not fortuitous. The interconnection of mass in Michelangelo's drawings is certainly paralleled in the flexible movement of the bodies of the divers, which are endowed with the same fluidity of handling of the pattern of movement which they establish. Léger was to say, 'I have looked hard at the figures painted in the Sistine Chapel: they do not fall, they are attached to the structure itself; one can even distinguish the form of the nails on their big toes. I assure you that when the Marseilles youths were plunging into the water, I had no time to note those particulars, and my divers are really falling.'

During his stay in the United States, the painter travelled widely throughout the American continent. He taught at Mills College in California and gave lectures that were aimed at reinforcing, with the spoken word, his interpretation of mass and space. In August, 1933, the title of the lecture which he had given aboard the ship in which he was returning from Greece with le Corbusier had been *Architecture with regard to Life,* and that which he had given in Antwerp in November, 1937, had been *Colour in the World.* He pursued a personal campaign with sincerity and conviction. His travels through the woods and deserts of the American countryside provided the inspiration for a whole new series of marvellous landscapes. The joy of the countryside and the fresh and exhilarating light which permeated *Papillon et fleurs,* 1937, and even *Le Paysage aux vaches,* 1937, and at an even greater distance the *Paysage animé* of 1921—much more mechanical however—returned in these paintings. Contemporary life in the United States is reflected in the greater complexity of these paintings, in their more excited rhythm. A painting like *Les Fleurs dans les éléments*
Pl. 21 *mécaniques* includes organic elements derived from nature which have been transformed or made significant: helical petal forms, branches and stems set against each other and mixed up with purely geometric elements. The composition is dominated by an overall tension and its impact is accentuated by the curved form, blue and white at the centre, which traverses the whole. But despite the interruptions and violent contrast, the composition has a balance which is largely attributable to a few stabilising elements, like the green mechanical form to the left. We also note how in a great number of works by Léger, black features prominently in the principle of contrast. *La Forêt,* 1942, *La Racine dans la rue,* 1944, *L'Arbre dans l'échelle,* 1943–4, *La Boîte à chapeaux polychrome,* 1943, and *Le Paysage américain aux oiseaux,* 1943–4, are among the best works of this period. Much later, they are returned to magnificently in the *Paysage romantique,* 1946, and *La Roue et*

l'échelle, 1947, which shows, as I have already said, that Léger's work is at times made up of recollections and repetitions: or rather an adaptation of familiar elements in the context of a surer development—in other words, a 'continuity'. We could also add the example of *L'Homme au melon* of 1943–4 which echoes in its style and composition, the *Composition aux deux profils* of 1933. *L'Homme au melon* is a work of which I am particularly fond, on account of its brutal frankness: it is hard, relentless and schematic to the fullest possible degree. The artist has given up the modulations of the forms; the figures and the other elements are rendered with the same handling so far as colour is concerned. The forms stand out against the almost neutral

Pl. 22

18 *La Danse*
1942, oil on canvas
Musée Léger, Biot

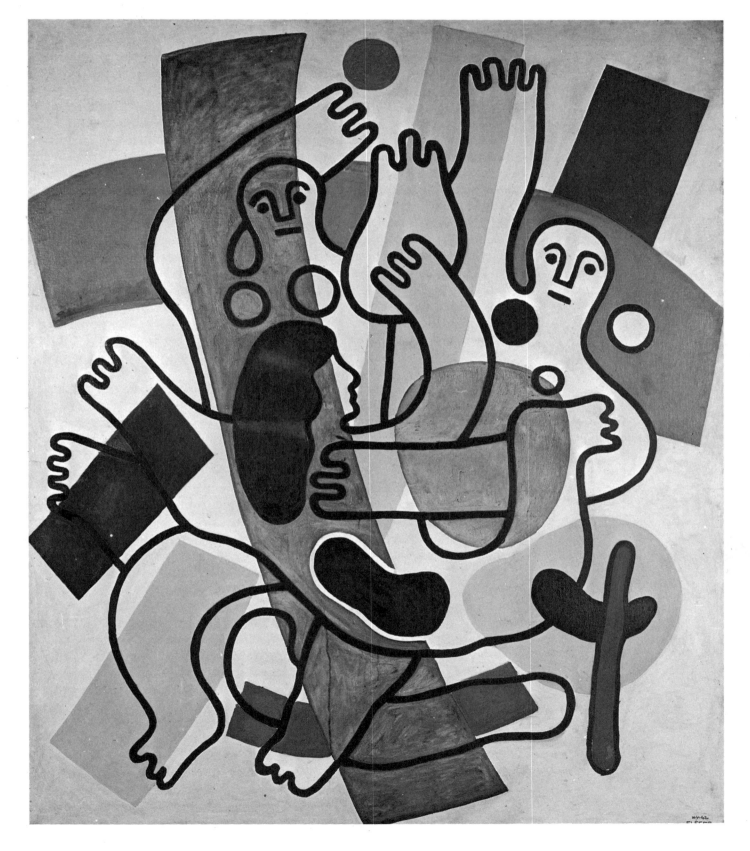

and bare background with surprising vigour. It is a composition with a great deal of impact, seemingly drawn with powerful strokes of an axe whose rigid vertical emphasis is barely modified by the flexible movement of the central curves and the assembly of semi-figurative forms that make up the still-life, dominated by the melon. Although the colours are essentially treated as surface values, they also contribute to the effect of form through their tones.

In New York, Léger liked to go to the circus or the music-hall. One thing especially fascinated him here – the movement of the spotlights moving across the stage with changing lights, objects and faces suddenly illuminated by a ray of coloured light. The circus and music-hall are located on Broadway; when the artist went outside he was immediately engulfed in the colours of the illuminated advertising that filled the street. 'One is there, talking to someone, and then all of a sudden he turns blue. Then that passes, the colour fades and is replaced by another, he turns red, yellow. This colour, the colour of the spotlight, it is free, it is in space. I wanted to do the same in my paintings. It is important for mural painting because it has no limitations of scale, but I have also made use of it in my easel paintings.'

This idea, that stemmed from the world of the music-hall and Broadway, was soon crystallised in a new technique that Léger developed: this is the period of painting beyond drawing. Colour is independent of the linear background, while the forms extend undisturbed from one area of colour to the next. The bands of pure colour which cross the canvas are like strips of light and luminous shade, just as if a number of spotlights had been directed at the painting at the same time, animating the immobility of the forms represented with the changeability of the rays of light.

Pl. 3 Writing about *La Femme en bleu*, of 1912, Léger wrote that it was in that painting that he first achieved rectangles of pure blue and pure red. In the new technique that he adopted for *Les deux Femmes à l'oiseau*, 1941, and for a number of compositions continuing the theme of *Les Plongeurs*, he returned to this use of rectangles. The contrast emerges between the descriptive course of the line and the rhythm derived from the coloured areas.

Social conscience
Pl. 23

Pl. 24

Following *Les Plongeurs*, Léger's lyrical approach was considerably enhanced. *Les belles Cyclistes*, 1942–3, is representative of this period following *Les Plongeurs*. The movement of his figures becomes more alive, the faces and bodies become more and more human. They are much less suggestive of mechanical robots. The colour technique of this period was to continue for a long time, right up to Léger's death in 1955. One of the purest and most explicit works of this period is *La Femme lisant*, 1949. Here the emphasis is on clarity of design; the composition is ample, light and as usual, extremely concise. The bands of colour cover the area of design and derive from it, but they also maintain their independence. All the beauty and indeed all the tenderness of this figurative painting, lie in the middle band of luminous grey colour. Although the colour lies outside the drawing, the effect of both is nevertheless complementary.

In 1949 Léger designed the backcloth and the scenery for the opera *Bolivar*, by Darius Milhaud and Jules Supervielle, and he employed the same technique of 'separate colour'. *Bolivar* was a difficult production. All the technical resources possible were employed: movement of parts of the scenery, movement of the flags (those of the United States and the South) and the transformation of the spotlights into coloured lights.

Les Musiciens, 1944, *Les Plongeurs noirs*, 1944, *La belle Equipe*, 1944, *Six personnages sur fond rouge*, 1944, *Les Acrobates*, *La grande Julie* and *Le Cirque* are works which show the direction taken by Léger's art towards the end of his stay in the United States. With regard to that country he said: 'Bad taste is a distinctive characteristic of this country. Bad taste, strong colours: the painter has everything to reorganise and can make the fullest possible use of his powers. Girls in sweaters, their skin a fiery hue, girls in shorts, dressed like circus acrobats. If I had only seen well-dressed girls, I

would never have painted a series of cyclists nor especially *La grande Julie*.'

Many paintings which belong to the series of circus artists or that of the cyclists were only finally completed in Paris after Léger's return from the United States. *Adieu, New York,* 1946, is his farewell homage to the nation which had been so hospitable to him for the duration of the Second World War. It was a prolific period for him: in six years he had painted more than 120 paintings and his notebooks were full of gouaches and drawings.

In Paris, Léger returned once more to his studio in rue Notre-Dame-des-Champs, which he had left in a hurry shortly before the arrival of Nazi troops in 1940. His first concern was to broaden the attendance at his school of painting, which he had founded together with the Purist Amédée Ozenfant in 1924, as he enjoyed so much working with young people. 'The young and the workers have always been my real audience.' The exhibition presented by Louis Carré in the same year, 1946, marked his success on his return to Paris. The fame he had achieved in the United States began to have its impact in France. Young students, teachers and art critics flocked to hear him lecture at the Sorbonne, to hear his unpretentious style that was straightforward, full of imagery and occasional bursts of slang. He would speak of what he was ever interested in – knowing art, his own, that of other people, the social function of this art and its destiny, in which his forecast of collective work and the future happiness of the masses gained authority in the quiet eloquence of his speech. He himself provided the commentary for the short film made in the United States by Bouchard entitled *Léger in America*.

His popularity grew not only in France but in the whole of Europe: the northern countries recalled their old enthusiasm for his art and revived it. Exhibitions came in quick succession. 'On the occasion of every important exhibition of my works in a museum or private gallery, I cannot but think of the first contract I was offered in 1913 by the art-dealer Kahnweiler, after which he bought nearly the entire contents of my studio . . . It was a difficult and beautiful moment. I believe however that my mother, who regretted all her life that I had not become an architect (a sound and profitable profession, she kept telling me), never came to believe in the genuineness of that contract', Léger related.

Fernand Léger had as it were emerged from himself: discussions, lectures, commissions for decorations and wall-paintings, paintings, waiting to be completed, journeys. In 1948 the Ballet des Champs Elysées entrusted him with the design for the scenery and costumes of Prokofiev's *Pas d'acier*. In the same year he executed a forty-metre mural for the International Women's Congress at the Porte de Versailles in Paris. Later it was his friend and neighbour in the rue Notre-Dame-des Champs, Janine Charrat, who called upon him to prepare the scenery for a ballet dedicated to Leonardo da Vinci. Léger employed some of his students at the studio on some of the scenery arrangements. He himself would produce the sketches, and they would be translated to the final scale under the direction of the painter Georges Bauquier, the director of the school. The studio was a veritable beehive where work was assiduously pursued in freedom and friendship, where each and every student could develop his own style, thanks to the principles so dear to Léger himself.

While the machine had disappeared from Léger's work, and while the still-life continued to gain density through the 'static-dynamic contrast of real objects with each other or of the same objects surrounded by imaginary forms, the human form and profile are seen in a light that is continually more social and collective. The political conscience of the painter weighed upon and influenced his creations. Léger tends to direct his inspiration towards a vast representation containing successive scenes, which relate to our own age like so many emblems, in which work, leisure and popular holidays will be celebrated in harmony with a felicitous freedom. This is the freedom to which the painter aspires: it is endowed with the force of his hope that it should come to govern the experience of all, but most especially

that of the working people, with whom Léger had a real affinity in heart and mind, and to whom his work owed in fact so much. Before these inspired hopes had begun to take shape in the United States, Léger had already written his ideas down: 'A problem worthy of David is emerging. Who is the young man with strength enough to resolve this problem, that is at once human and three-dimensional? My mind turns to the primitives, to popular art, to the art of the Mexican Orozco, for example. After having painted *Le Mécanicien, Les Musiciens, Le grand Déjeuner, La Ville,* I often worried over these problems that are those of monumental paintings. I was struck with some of the compositions of the Italian old masters—Carpaccio and Bellini. It is a field which we have avoided. David, I repeat, because he approached the solution of the Ingres-Delacroix question; Courbet, in contrast to Rubens, reached it by the use of contrast, pure colour and the grouping of forms. That is the achievement of thirty years of small paintings. One must, therefore, broaden the problem. Four apples on a table are transformed into ten figures in three-dimensional movement. Faces, eyes, feet can be in their right places if the general arrangement of the composition is well done. They then provide material for variation instead of anecdotal details.'

Homage to David

The first paintings of the great and prolific series of *Les Loisirs* were sketched, as I have already noted, in New York. Their completion occupied the space of many years in France, from 1947 onwards, until, in fact, Léger's death. With regard to these paintings, that are so decidedly keyed to a subject, I can still hear Léger exclaim, 'But good God, I am not painting subject-pictures, I am painting, not creating descriptive literature. We ought to agree once and for all on the meaning of the word subject . . . I could even accept it, but only on condition that it be circumscribed with the observation of my aesthetic principles! Just the same applies to the word decorative . . . I agree, but here too we ought to reach an understanding . . . Decorative art is based on a single melodic line. "Greater" art is always based on counterpoint, two ideas set against each other. I have followed this principle in my paintings.'

Hommage à Louis David, 1949, is a masterly composition, and one which is reflected and extended in the great paintings of *La Partie de campagne, Le Campeur* and *La grande Parade.* The imagery is wholly figurative, the abstract elements have disappeared altogether. We are presented with the image of figures out on their Sunday walk, two men, a woman and a child meet up with a woman and a circus child and some acrobats. Two bicycles make up part of the composition, the usual mechanical elements that play a more important role than the figures; a fence, a tree, branches, flowers, birds flying around the clouds add a country note. The painting reveals a serene and profound joy in life, an impression of clean living, a gentle intimacy, conveyed by forms that are full of depth, colours that are rich and tender, and warm like summer loaded with ripe fruit. The soundness of mass represented is so beautiful to look at that it appears to be on the point of bursting. The background is three-dimensionally pure, but one cannot help being reminded of the cloudless skies of holiday time, when the sun pours down. The reclining cyclist holds in his hand a sheet of paper on which is written 'Homage to Louis David' movingly and almost naïvely epitomising Léger's admiration for his great nineteenth-century predecessor. The clarity of the idea is rivalled by the simplicity of the execution. While the hardness of the handling has become less emphatic, it should be recalled that this hardness never implied dryness, even in the mechanical period. The *Hommage à Louis David* is evidently the product of a calculating imagination, in which nothing is left to chance. This logical engineer's approach combined with the dedication of the devoted craftsman result in a lofty and austere art, which may suggest an analogy with the elevated sentiment of a hard-won happiness. The painting, which is the most cheerful and attractive of Léger's works—the subject-matter of a popular holiday and a display

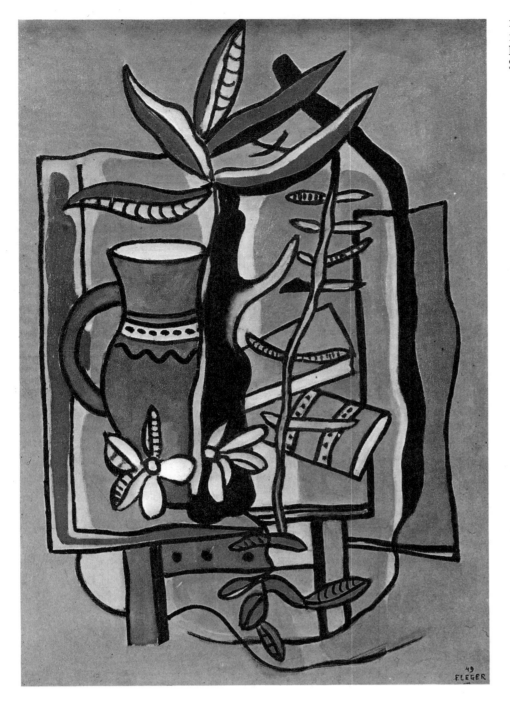

ensures that—contains also an inherent gravity. The technique is not solely technical in character, not only an extremely adaptable and inventive tool at the artist's disposal; it acts above all to reinforce the idea behind the creation. Although the painting seems simple and to have stemmed from a momentary burst of creativity that is elementary in nature, it in fact stirs up inner motivations which demanded all the courage and indeed heroism that the painter could muster. In a preface written for a book on Léger, Cercle d'Art Editions, Paris, 1955, written by Pierre Descargues, the painter himself writes so overwhelmingly that we cannot but be encouraged to penetrate a world that is much more profound than we had imagined. Among other things he says, 'The tramp sleeping on his bench and the artist who has reached the peak of his creativity have one thing in common: love of freedom—action in freedom—suffering in freedom. The former has lost the race, the latter won it; but they both started the race on the same horse. Artist, poet, creator of beauty are alike committed to this heroic destiny—to "act in freedom". This freedom which one loves so much, this day of glory, involves a daily and incessant risk. These living creations have been conceived and forged in conditions of open opposition to society.

'That is your life, day by day. In the future (if you are still around) you will recount it to your friends and admirers. Tears will come to their eyes.

'In this adventure which no mother could dream for her own son, he will have created paintings, poems, symphonies, for which museums and libraries will be built. It is through freedom that it is possible to create these things, a freedom that is at one with the study of the new elements in one's contemporary environment, which the artist observes in his solitary isolation.

'A new art makes its appearance, finds its place and is added to the master-pieces of previous generations; strangely, it will be observed in the future that in retrospect it was not so revolutionary as all that, that it drew on the old traditions with which it had to struggle, from which it had to free itself altogether. It is a play with many acts. It is in this way that it comes to an end.'

Pl. 26–27 *Les Loisirs,* which is illustrated here, is very similar to *Hommage à Louis David.* It is barer, with a good deal fewer features around the central subject, but it shares with it the same characteristics in the faces and forms of the figures, and it is composed in a like manner; the expressions and gestures are similar, and it is founded on similar principles. Everything is located in a clear space, and the simplicity of the whole is founded on a great, almost condensed strength, in which happiness, humour and solemnity are combined.

Pl. 43 By comparison, the work entitled *Le Campeur,* 1954, has a much more striking use of contrast, deriving from the juxtaposition of mechanical elements (the pillar and beams) with the human elements (the figures absorbed in gentle pastimes) and the vegetable elements (the tree, cactus and flowers). The movement represented by the hill in the distance—a feature taken from the landscapes of the American period—gives the immediate impression of a plane-perspective. The world of the working classes, the world of pastimes and holidays are closely linked in a happy wholeness. The surrounding nature is at once free and subject to man, and it represents a grandiose and placid friend.

Art and sacred art In 1949, Léger's many-sided activity was marked by an important under-taking—the creation of the vast mosaic for the façade of the church at Assy, in the Haute Savoie. The work had been suggested to Léger while he was on a visit to New York, by Father Couturier, a patron of the arts and of modern artists. As early as 1946 Léger had prepared a sketch for the design, and it was this one which was accepted.

The artist had no religious feelings and made no attempt to conceal this fact, as is evident from some of his comments that were published in the review 'Zodiac' produced by the monks of the Abbey of Pierre-qui-Vire. 'It was not faith that caused the artists of the Middle Ages to paint so many beautiful things. This view has, I know, been shared by many, but I cannot support it. For me, their work is objectively beautiful, because of the inherent relationships and aesthetic effects, and not for sentimental reasons.' To me too, in his declaration incorporated in my book *Léger ou le dynamisme pictural,* the artist took pains to reinforce, in 1954, his earlier convictions: 'I am convinced that it is the same man who created the United Nations panels and the Adincourt windows, the same 'free' man. I have never compromised. To celebrate sacred objects, nails, ciboria or crowns of thorns, to treat the story of Christ represented no contradiction for me. I am sane, and my spirit has no need of props. They represented unexpected opportunities for the decoration of vast surfaces according to the precise principles of three-dimensional design I had evolved. I was put under no pressure, it was a question of take it or leave it. I was interested solely in producing a pattern of forms and colours that was relevant to all, believers and non-believers alike, something that was useful, accepted by all for the simple reason that it brought joy and light to the heart of each. The Dominican Father Couturier supported me all the way. In connection with my

work at Assy he remarked, 'I do not want to concern myself with the political or religious opinions of this or that artist, what matters is only the work of art in the pursuit of the Beautiful.'

At Assy, Léger represented the litany of the Virgin. Not being familiar with the technique of mosaic he began to study it, and he entrusted himself to the guidance of some mosaic workers in the actual execution of the work, allowing them to share in the actual creative process and not regarding them as mere workmen. This approach coincided with the teamwork that was a characteristic of the studio, and it was the same spirit of collective creation that characterised the work on the Bastogne Memorial, Belgium, 1950, the windows for the churches at Adincourt, Doubs, 1951, and Courfaivre, Switzerland, 1953–4.

At Adincourt Léger, faced with the doubts and hesitation shown by some of the local dignitaries before his bold designs, invited the local inhabitants to come and examine his sketches. The reaction was enthusiastic and those who had previously hesitated now readily supported the project. Today believers and non-believers flock to Adincourt on a pilgrimage for the eyes and heart: one can affirm that these windows are among the most magical in the world and that the story of Christ that is represented in them is translated into sublime aesthetic terms, to the exclusion of all sentimentality. Even so, the drama of it is bound to have an impact, whatever our religion or philosophy. While retaining its mystical quality, it has significance for us all beyond the original Christian meaning, in the implication that light will ultimately triumph over darkness, and that within us there shines the everlasting light of peace.

After the celebration of pastimes, that of work: in the extraordinary series of *Constructeurs,* which begins in 1950. It represents a sort of generous challenge at the moment when abstract art, geometrical or Tachist, enjoyed its greatest artistic and commercial success, and equally at a time when the works of so-called social realism were only mediocre comparable with the most conventional and unimaginative creations of the petit-bourgeoisie. Form and content in *Les Constructeurs* affect each other reciprocally. And form continues to make itself more relevant through the renewal of modern inventions, charging them with new energy.

So far as the content is concerned, it is decidedly social in nature, it pays homage to work and to the dignity of the worker. Let us hear what Léger himself has to say: 'When I created *Les Constructeurs,* I made not a single three-dimensional compromise. It was in going every evening to Chevreuse on the car journey that I got this idea. A building was being erected in the field on the way there. I saw the men swaying high up on the steel beams: I could see man like a flea, he seemed lost in the scale of his own creation, with the sky above. I wanted to show this: the contrast between man and his inventions, between the worker and this steel architecture, this hardness, this ironwork, these bolts and rivets. I have arranged the clouds too in a schematic fashion, but they also contrast with the beams. No concession to sentimentality, even though the faces are more varied and individual. I try to renew myself without leaving hold of the problem. For me the human element has a development, like that of the sky. I place greater emphasis on the existence of the figures but at the same time I dominate their movements and their emotions. I believe that the truth is better expressed that way, in a more direct and durable fashion. The anecdote is soon seen to belong to its period.'

The characters of *Les Constructeurs* are a good deal more prominent than those of the figures in the pastimes; they illustrate the activity to which they belong, and the same is true also of the *Partie de campagne* which followed. We have already had occasion to note this, in the instance of the description of *Le Campeur.*

Léger would go every day to his studio in the rue Notre-Dame-des Champs, but he felt himself drawn more and more to the calm of the country

Reality and abstraction

Pl. 25

and he needed ample space in which to work. So in 1952 he set himself up at Gif-sur-Yvette, not far from Paris in the Vallée de Chevreuse; soon he had spacious studios there, all painted white. Dividing his time between Gif-sur-Yvette and Paris in parallel with and as it were in counterpoint with his *Partie de campagne* and *Constructeurs* theme, he set to painting yet another new series of landscapes, inspired by the Normandy of his youth, where he liked to return occasionally. These landscapes are conceived specifically for the medium of easel painting, and the canvases are never more than middling in size. Their freshness, robust grace and cheerfulness reveal Léger's sometimes almost naïve passion for the countryside. A certain tenderness springs from the movement of lines and the arrangement of the colour, as is illustrated in the magnificent composition entitled *La Chaise et la vache*, 1952, which is a sort of affectionate homage on the part of the painter to his peasant origins, to his native country.

Sometimes the landscape assumes a mechanical character once again: the high tension wires and electricity pylons march across the countryside, in direct contrast to the trees, as we see in *La Maison jaune et l'arbre vert*, 1952, which is very aggressive both as regards the contrast of angular, linear and curved forms, and in the colour, in which shaded tones are set against wide bands of pure colour. A similar objective contrast of opposites is to be found in *Les cinq Tournesols*, 1953, while in the previous landscape the view appears to be caught as it were at high speed, as if from the window of a racing-car (we are reminded of the almost daily journeys Léger made between Gif-sur-Yvette and Paris), in the second landscape the view is 'fixed' to the extent that the plants and iron beams appear to advance naturally before one's eyes, emerging from the same point in the foreground of the landscape, profiled emphatically against the tranquil horizon of hills in the background. The metal objects (pylons and beams) are combined with the beautiful (the flowers) and the result is perfect harmony. Arranged in this way, the manufactured object does not seem out of place in this transformed landscape, transformed because of the industrial age. Fernand Léger seeks to illustrate here, in this example of a painting taken from a landscape, that the pace of a mechanised existence can be reconciled with that of the countryside, that nature can maintain all its charm despite the intrusion of the elements that might appear to be hostile towards it.

On the 21st February of the same year Léger married Nadia Khodossievitch, who had come to France in 1924 to study under him, and who had been so often entrusted, together with the painter, Georges Bauquier, with the running of the studio during Léger's absences. One of his old pupils, Gregory, created the vast mural for the great hall of the United Nations in New York from Léger's sketches: it consisted of two vast surfaces, two walls each ten metres by ten metres. The architect Harrison approached Léger with the request, made after a long study of the problem, to give pictorial mass to one wall and deprive the other of it. It was a problem of balance in a case of static-dynamic tension. It provoked quite an uproar among the more reactionary members of the United Nations. During this period the artist was completing the mural painting for the Italian steamer Vulcania in his studio at Gif-sur-Yvette. The composition is abstract, powerfully dynamic, evocative of both power and movement at the same time, and also strangely, of the legend of the sea. The harshness of the colours, which are rendered as surface elements, reinforces and lends weight to the impact of the masses. The whole composition conveys a powerful sensation alternately of pitching and rolling.

While the abstract continued to fascinate Léger, it was solely in the context of the decorative or mural painting that he concentrated his interest in this direction. This interest is clearly apparent in the work reproduced here, entitled *Formes dans l'espace*, 1953. This picture does not play the role of an easel painting in the sense of being a collector's piece, ready to be displayed along with other collector's items, being above all a proposal for a mural in the mind of the artist.

Pl. 30

Pl. 36

Pl. 29

Pl. 35

1953 . . . The great final fireworks display—a fire that is not ready to be quenched, rather beginning to glow anew amidst the ashes, a prelude to the final bouquet that is *La grande Parade*, 1954, Léger's apotheosis.

The prelude is formed by the series of circus paintings, a series which owed its origin to Léger's undertaking in 1949 a series of lithographs in pure colours for an album for which the artist had also contributed the poetical text, a text full of wisdom and subtle humour. These lithographs had been created along with fifteen others which illustrated Arthur

La grande Parade

20 *Les Constructeurs*
l'équipe au repos
1950, oil on canvas
Musée Léger, Biot

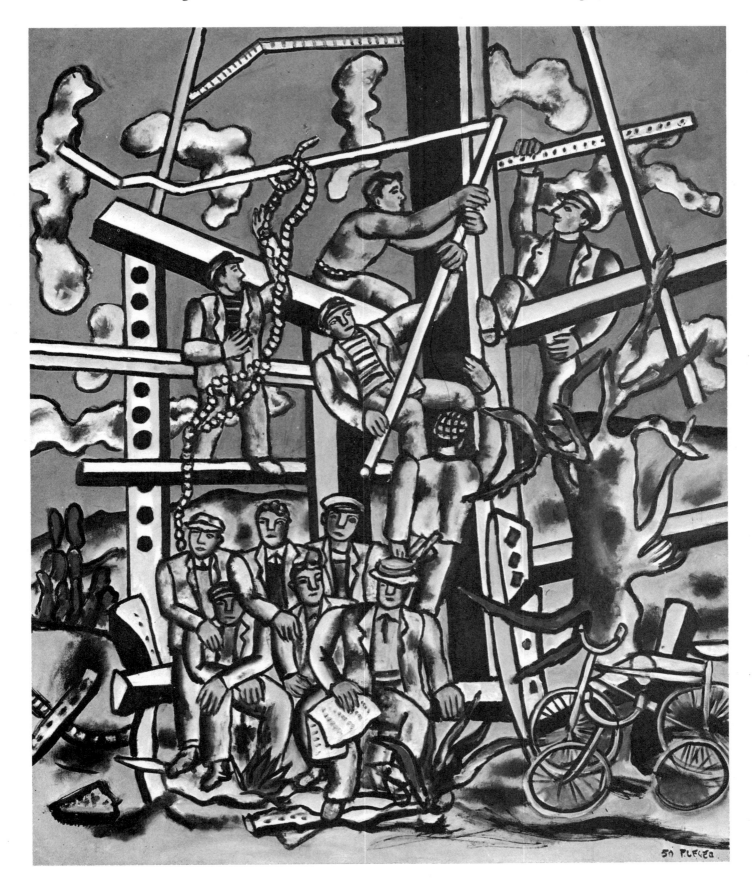

Rimbaud's *Illuminations,* a work which was one of the painter's favourites, along with those of Paul Eluárd, Aragon, Lautréamont, Blaise Cendrars, Apollinaire, Mayakofsky and others.

Pls. 37, 38 *L'Ecuyère noire* and *Le Jongleur et les deux trapézistes,* 1953, are illustrative of Léger's development at this point together with the well-known and vast canvas *Partie de campagne* of 250 × 300 cm. (about 8 × 10 ft.), also dated 1953. The figures are shown more as individuals, they are more humanised, closer to reality. As in *Les Constructeurs,* the clothes of the figures in the *Partie de campagne* are appropriate for the role which they play. There are four figures, two women and two men; the women are in summer clothes; one man is wearing a tie and his Sunday clothes, while the other has hung his jacket on a tree-trunk which in the interpretation of the painter takes the form of a tree-shape in the middle of the painting. The man in a sweater, turning his shoulders towards the spectator, occupies himself with a car with its bonnet up. A dog joins in this ballet. In front of this canvas one cannot help being reminded of the most beautiful days in summertime. Everything is clear, natural and airy. The colours vibrate in the light which is transformed into colour; the forms have relief, spread and distribution in accordance with the artist's desire, which is to represent a happy human environment against a country background, that of the paid holiday. Yes indeed, Léger has not forgotten the progress made by the workers, by the 1936 Popular Front and the social advances it achieved; for he felt very deeply about that movement and it seems to me that there is much of that struggle and success reflected in the complexities of this painting. But here peace reigns, there is harmony between beings, between objects and humans and it seems as though the gestures made by the figures on the right are, in their affectionate attitude, a sign of certainty and boundless confidence. And it is beautiful that all this should be, once again, suggested by a single three-dimensional effect, quite outside any figurative representation or demonstrative sentimental anecdote.

The composition of the *Partie de campagne* answers a desire for a static quality. There is nevertheless a dynamic element in the tree-shape in the middle of the composition, in which the movement is implicit in contrast to the gentle mood of relaxation. While the figures have lost a good deal of Pl. 31 that monumentality and severity, to which Léger occasionally returns, as in *La Femme à l'oiseau,* 1952 (almost as a reminiscence of the 1921 period and *Le grand Déjeuner*), they nevertheless retain something of the hieratic pose, and this despite the greater definition of their psychological character. *La Partie de campagne* also exists in a replica, which represents the final stage in Léger's development of the compositions, characterised by the employment of exterior colour, with broad coloured lateral bands. I regard it as too contrasted, and I prefer the first version.

Pls. 37, 38 The *Ecuyère noire* and *Le Jongleur et les deux trapézistes* are on the other hand very dynamic in their expression. They constitute a real ballet of forms in which the angles and straight lines are contrasted with the curved lines, in which the action of the figures and the animals in the foreground involves and projects forward the real objects and imaginary elements in the background. The form of these acrobats is reminiscent, by reason of the lightness Pl. 20 of their movement, to *Les Plongeurs* of 1942. But how far we are from the 'cylinder shapes', powerfully turned, in the mechanical and monumental phases of Léger's work, at what a great remove we are from the 'robot-figures', from the women with hair-like corrugated iron! But these forms remain nevertheless profoundly organic and functional.

Pl. 39–40 The canvas of *La grande Parade sur fond rouge* of 1953 is in a sense dedicated to drawing, which is here given prominence. It is a whole mass of lines and strokes which are orchestrated like movements and choral unisons.

Following numerous preliminary studies, *La grande Parade* emerges as a sort of fanfare during 1954. I regard it as one of the most compelling works of the whole series. Its youthfulness takes one by surprise, and it rests on the whole of Léger's pictorial experience and originality, constituting at once

its *summa* and its precise synthesis. The world of the circus provides the context for the construction of a solidity in which there is not the slightest imperfection, and in which the complex objective relationships are resolved with masterly simplicity.

La grande Parade represents the triumphant realisation, at a distance of many years, of the hopes that are implied in *Les Nus dans la forêt,* at the very beginning of Léger's artistic career. The theme of this vast canvas of 250 × 300 cm. (about 8 × 10 ft.) is a human legend as old as time, but one which is made relevant through a pictorial technique that is completely in tune with modern times. This celebration achieves monumental proportions, but the canvas vibrates with intensity and almost appears alive, such is the vitality of the complex framework which unites all the figures. This painting of happy circus peoples—the main subject—is paradoxically reminiscent of a well-functioning series of pistons and rods in movement, a whole assortment of pipes and valves. This impression is enhanced by half closing the eyes: the spinning motion accelerates and the dynamic quality of the painting becomes more emphatic as the lateral and circular bands of colour—quite apart from their function as colours—create a convincing illusion of backwards and forwards movement. After the initial theatrical impression, the figures and objects immediately return to their places, everything follows the rigid framework on which the work is founded in the luminous and coloured light of spotlights. Following this painting Fernand Léger began working in 1955 on another large painting, a painting of war: *La Bataille de Stalingrad,* which had hints of an even more vibrant dynamism, to judge from his first sketches for it, especially those showing Russian troops amidst an iron wilderness of destruction.

It was a subject that adapted itself perfectly to Léger the man, and one which was perfectly consistent with his artistic ideals, one where he would have earlier doubtless applied with even greater violence his principle of contrast. Here I recall one of his suggestions, 'A painting of war, if you like, a painting of a battle. It is very difficult to avoid the romantic, the sentimental . . . Few have succeeded with a subject of this sort, it is devastating . . . Paolo Uccello with his Battle—there is someone who has understood the problem well! What a lesson we have to learn from that master . . . I am studying him in depth. He applies the principle of contrast and sometimes I see a link with myself and his work . . . Look at those warriors, their weapons, the way in which he arranges everything, everything works, . . . Paolo Uccello really belongs to the mechanical era that precedes my own.' How marvellous Léger sometimes is, laughing in a malicious and naïve way.

A modern primitive

To draw himself closer to the popular mood of a movement, Fernand Léger in 1955 travelled to Czechoslovakia in order to participate in the Sokols demonstrations in Prague. He was pleased to be able to take with him the sketches for an important commission: those for a large mosaic mural for the Gas administrative building at Alfortville. The architect Niemeyer also asked him to work on designs for another mosaic: that of the auditorium of the São Paolo Opera. Here his grandiose dream of mural decoration could materialise in what was an active social environment. As early as 1949 his studio at Biot, directed by one of his old pupils, Roland Brice, had continued to produce dozens of sculptures and polychrome bas reliefs. One of the large-scale pieces, *Femmes au perroquet,* is now located in the garden of the Hôtel Colombe d'Or at Saint-Paul de Vence, not far from Biot. The majority of these works are designed in the specific context of the architecture which surrounds them. Léger showed this concern from the very start of his work in the field of polychrome sculpture. There is also great variety in his work, which may be for interior or exterior, static or dynamic in function. In this way the superb *Fleur qui marche* in the Musée d'Art Moderne in Paris illustrates effectively the idea of sculpture as 'form in movement'. Some bronze sculptures also carried through and reinforced the same themes as are found in the ceramic pieces. *La Branche,*

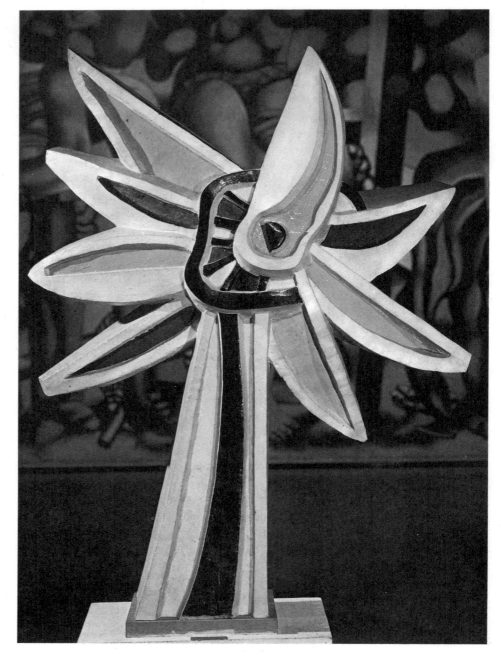

Pl. 28 1952, derives its ambiguity from the fact that, despite its title, it is more evocative of the animal than the vegetable world. It suggests a pair of animals with their progeny seen as a family, the gestures of the father and mother being protective and guarding ones. In this instance Léger was seeking to create a three-dimensional bond of strength and tenderness and establish a symbolic image with no anecdotal significance. The same is relevant in the instance of the polychrome mural sculptures reproduced here, which represent a moment of fulsome happiness and bright joy, fixed in space and time. 'Since first staying on the Côte d'Azur at Biot I have tried to capture the sun in my ceramics, giving the reliefs a broad scale,' Léger told me at the time. 'As in painting, I am constantly preoccupied with remaining faithful to myself, pursuing a path of no compromise, the opposite of sentimentality, which I have managed to impose on myself and from which I think I can say that I have strayed very little.'

Sadly, just as a well-merited fame had finally caught up with Léger, placing him and his work in a context of universality, he died, on the 17th August, 1955, at Gros Tilleul, his country house at Gif-sur-Yvette.

His had been the last saving blow to the foundations of conventional painting with the introduction of the machine and the manufactured object, endowing them with dignity. At the time he was accused of

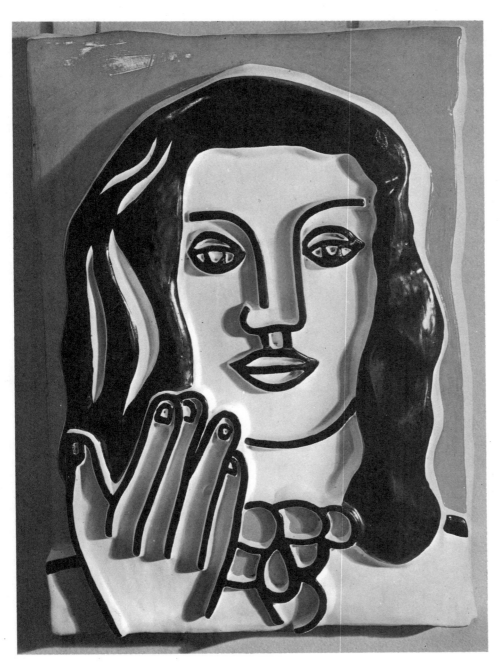

vulgarity, so great was his impact in terms of brutal frankness of forms and colours. Today his work emerges triumphant, with its dynamic strength derived from the peaks of tension. Léger is one of those who has contributed most to the concept of mural and decorative art, and to the social interpretation of the art studio. More than anyone else he raised the art of advertising to new prominence, particularly in connection with poster and window design (objects in space). He was so far in advance of his time that his contemporaries did not see him for what he was, since they had been too far overtaken. As a painter he had already assimilated the industrial world at the very start of its appearance, and he had moved on to the future. An intrepid inventor and demolisher of forms, indefatigable in his renewal of colour, he brought new life and energy to painting for years to come, providing it with ample practical opportunities for development. He loved youth, and the youth of today is beginning to see the broad rhythm of his youthfulness.

As regards the artists of the new generation, those who claim to belong to the avant-garde, and I am thinking particularly of those who describe themselves as New Realists and Pop artists, many of them if they involve themselves in argument at all do in fact admit the fact that they are directly influenced by Dada and Léger.

This man who emerged from the people never in fact set himself at a remove from them, despite his success and fame. His whole life as an artist illustrates an exemplary struggle, courage and generosity.

A genial and kind giant, friend of poets as much as of peasants at a fair, the initial severity of his expression became immediately transformed into a kindly warmth as soon as human contact was established. One was struck as one watched him draw by the extreme refinement of his hands, that were those of a musician, of a handler of extremely delicate wings, quite in contrast with the strength of his frame. And these hands, which had dared to paint machines, were painting flowers when they were stilled by death.

Fernand Léger, Cubist and primitive of modern times as he has sometimes been called, the poet of pictorial dynamism, loved at times to pick flowers along country roads and make them up into a bunch, the same, doubtless, as that which he placed in the arms of his great Juno figures (or Julies) in his paintings.

Colour plates

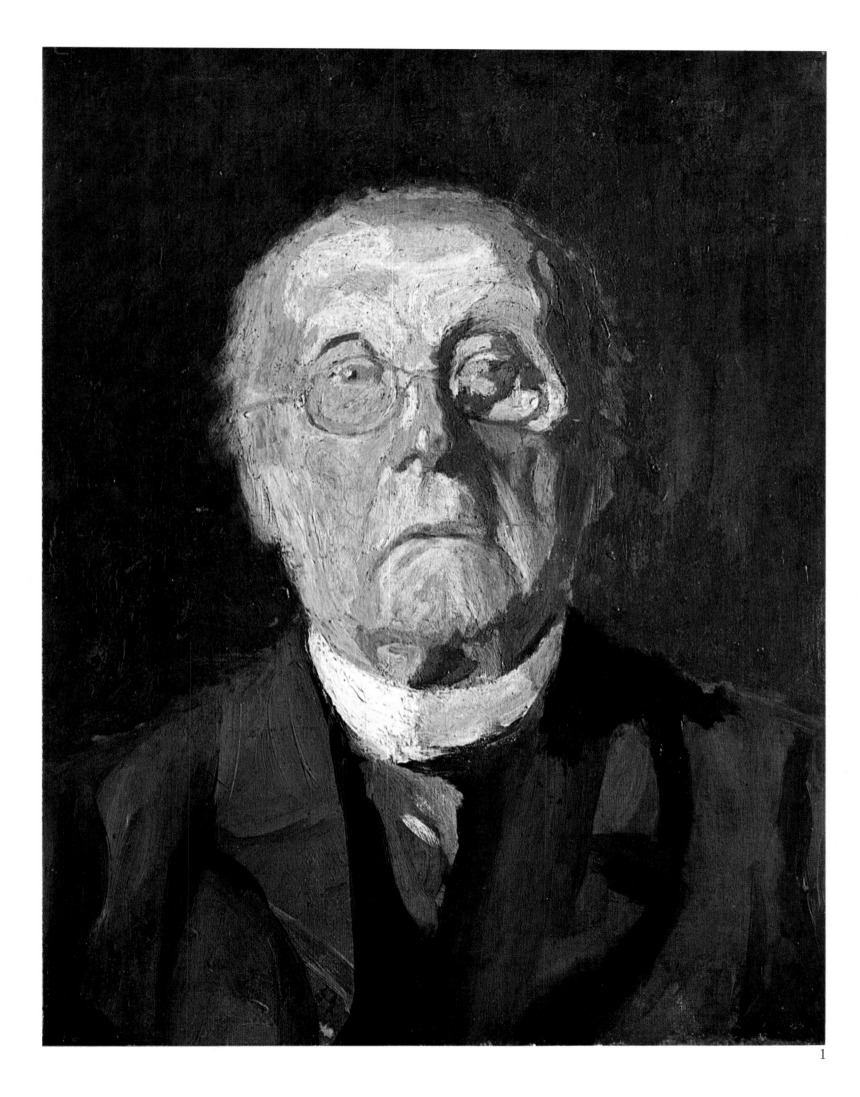

1

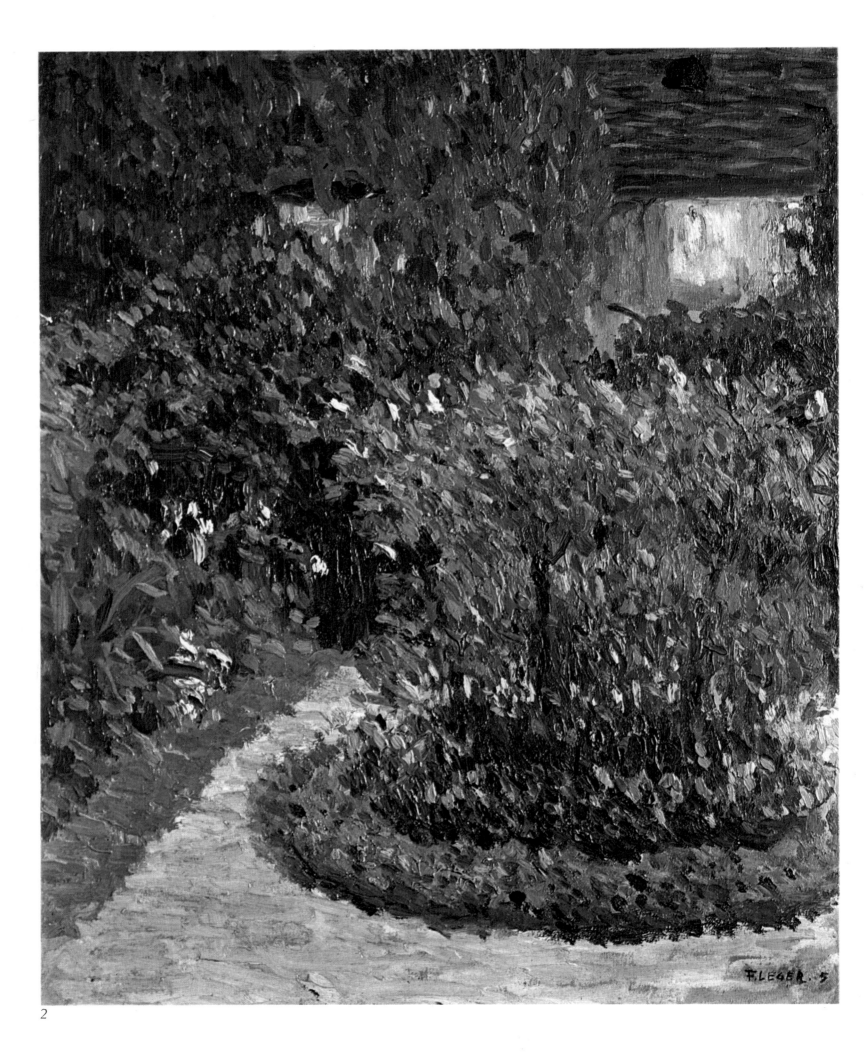

2

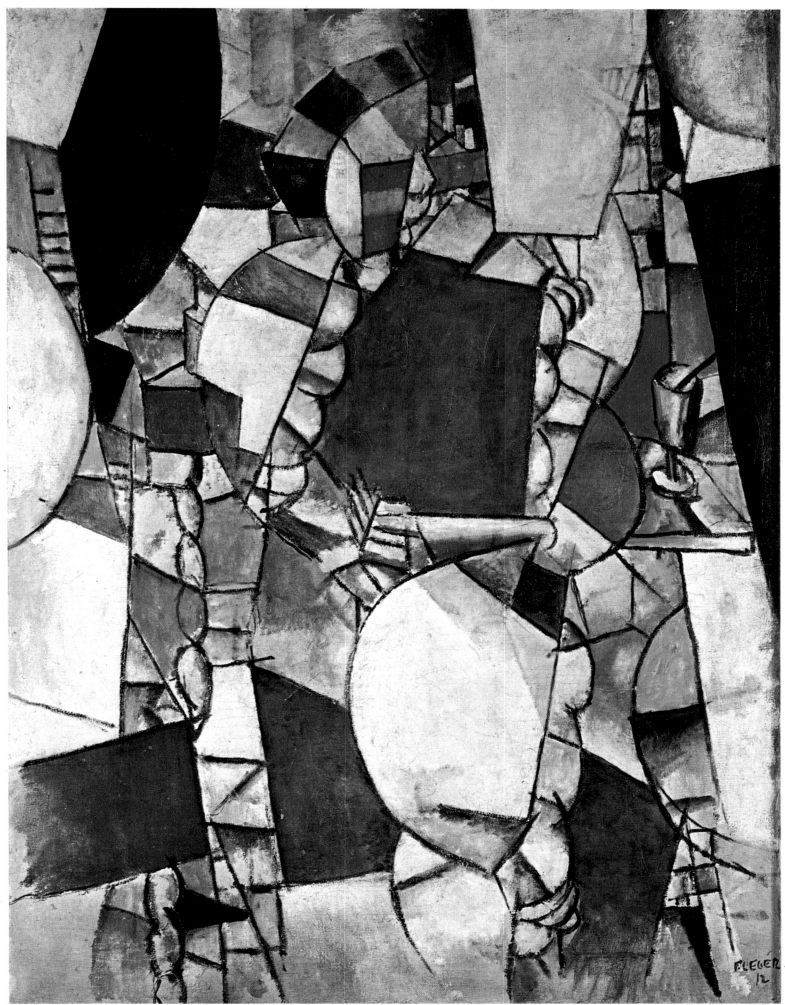

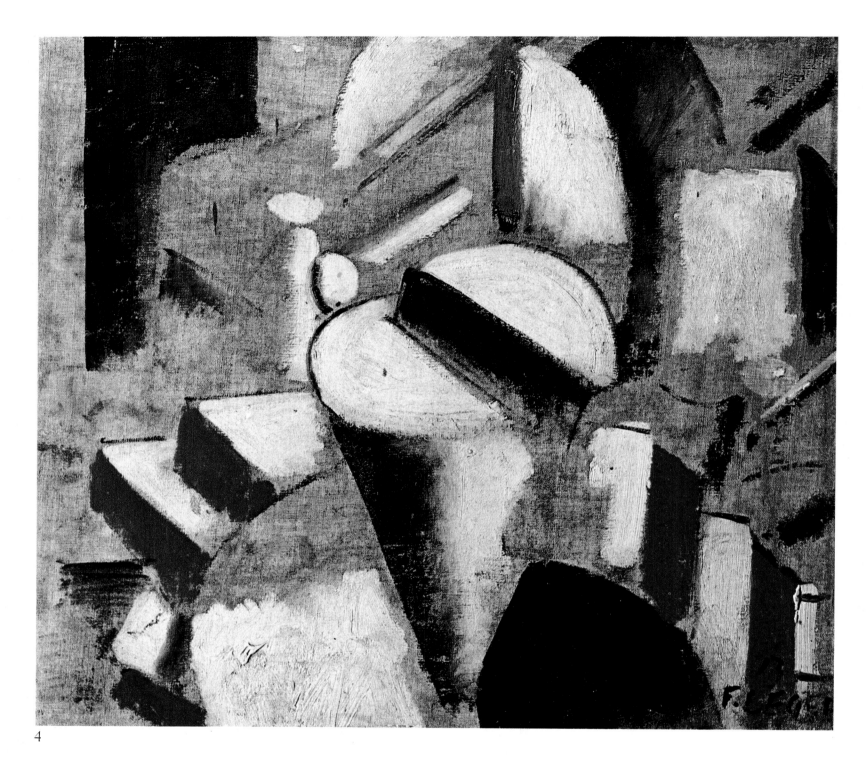

4

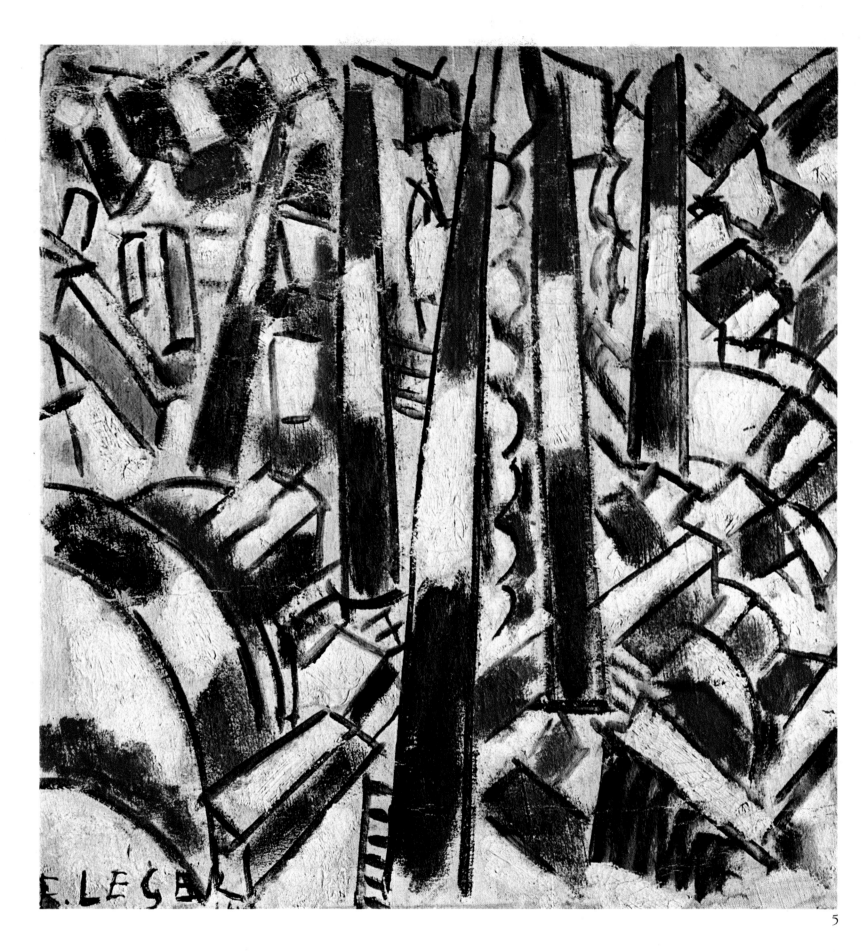

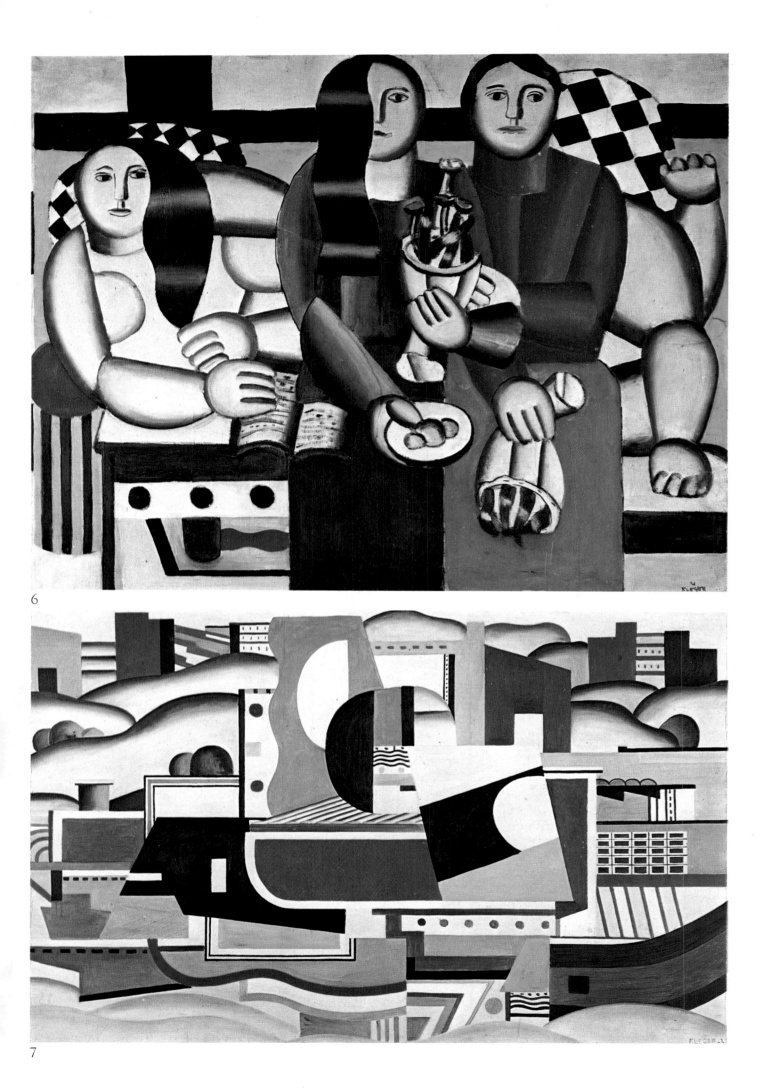

6

7

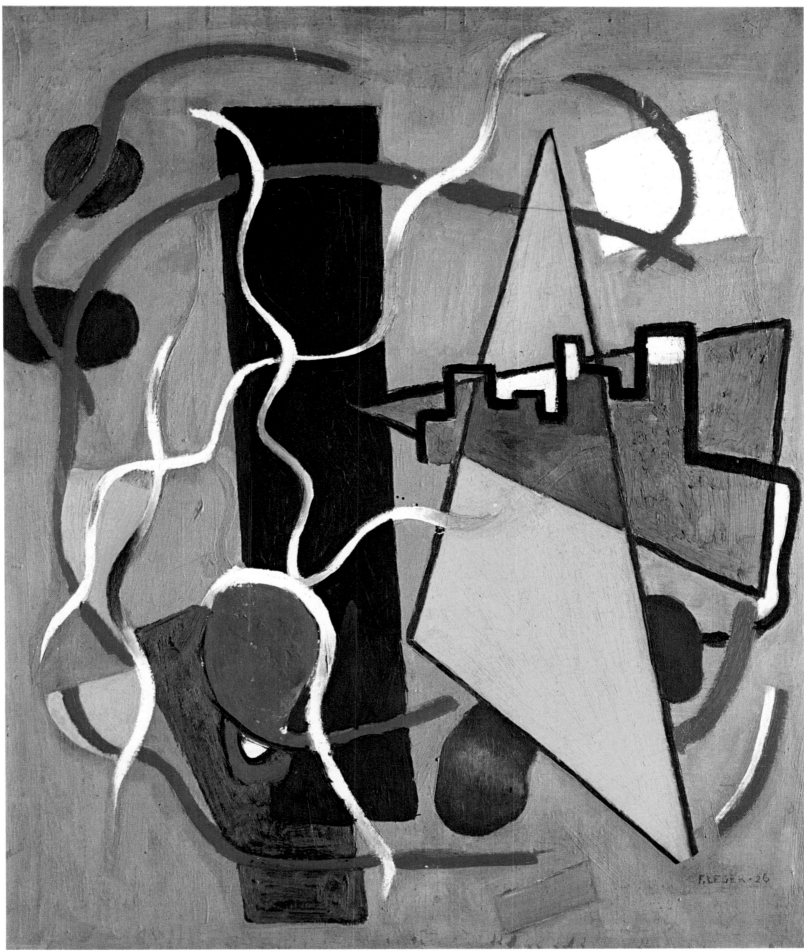

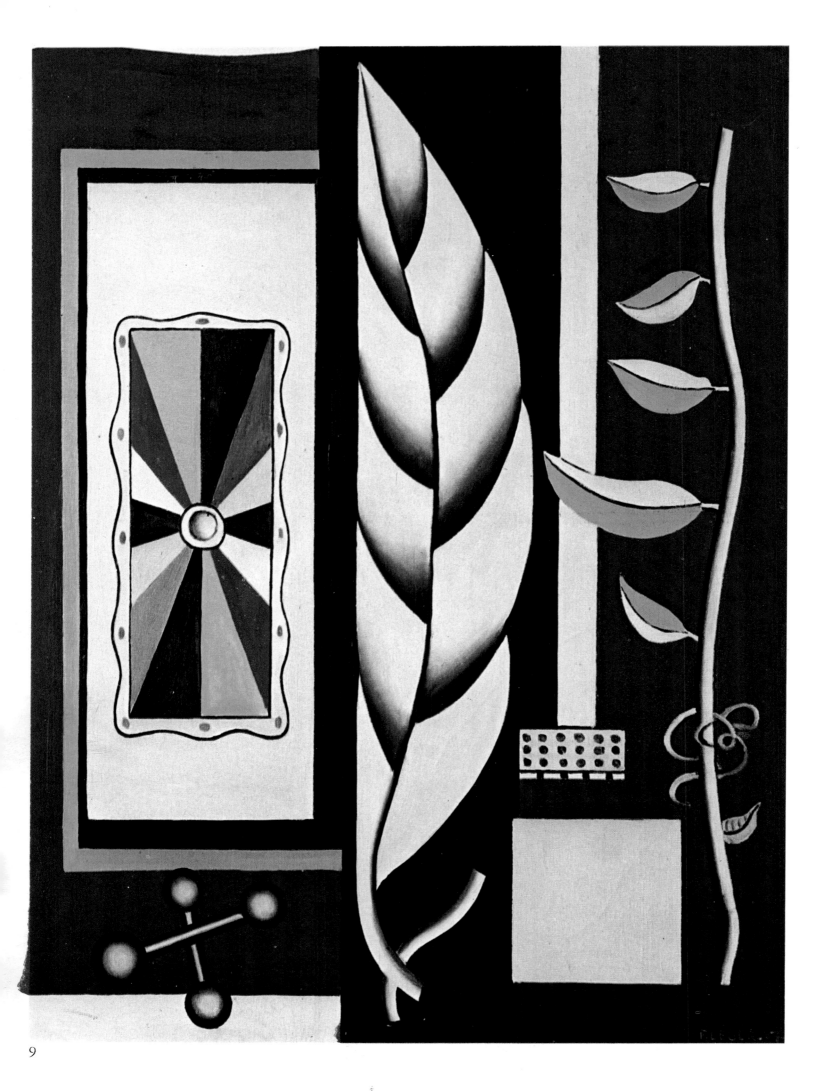

9

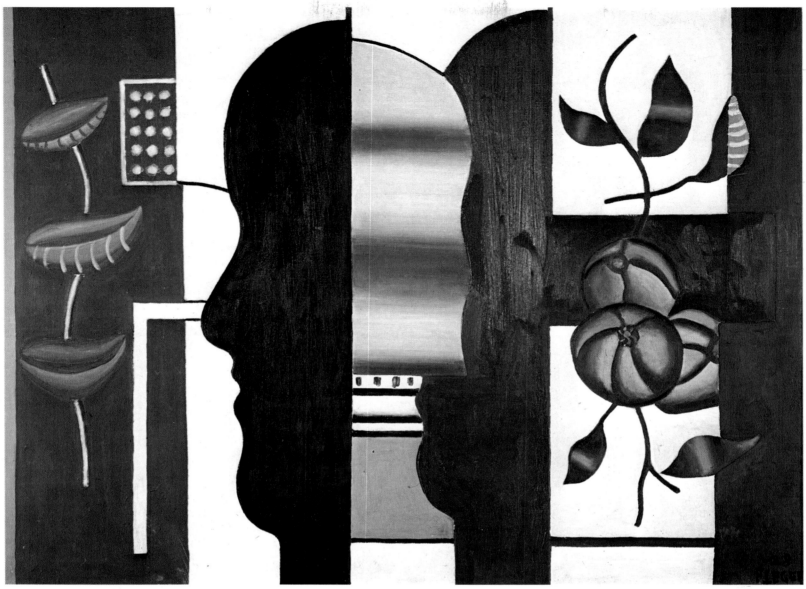

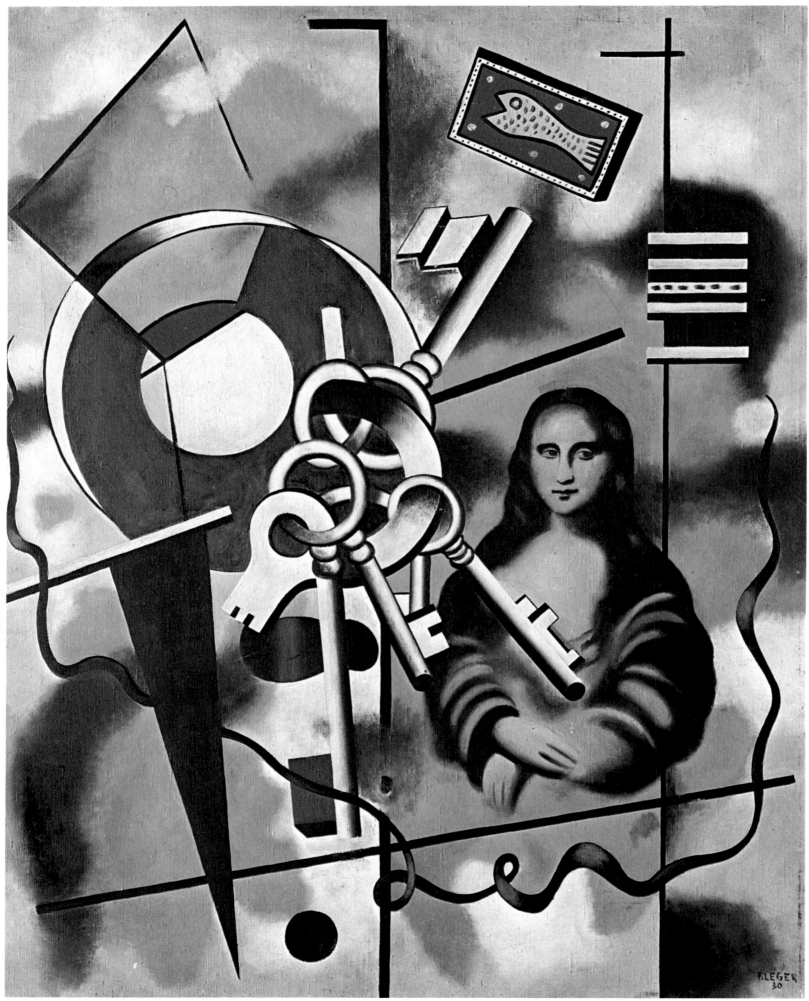

11

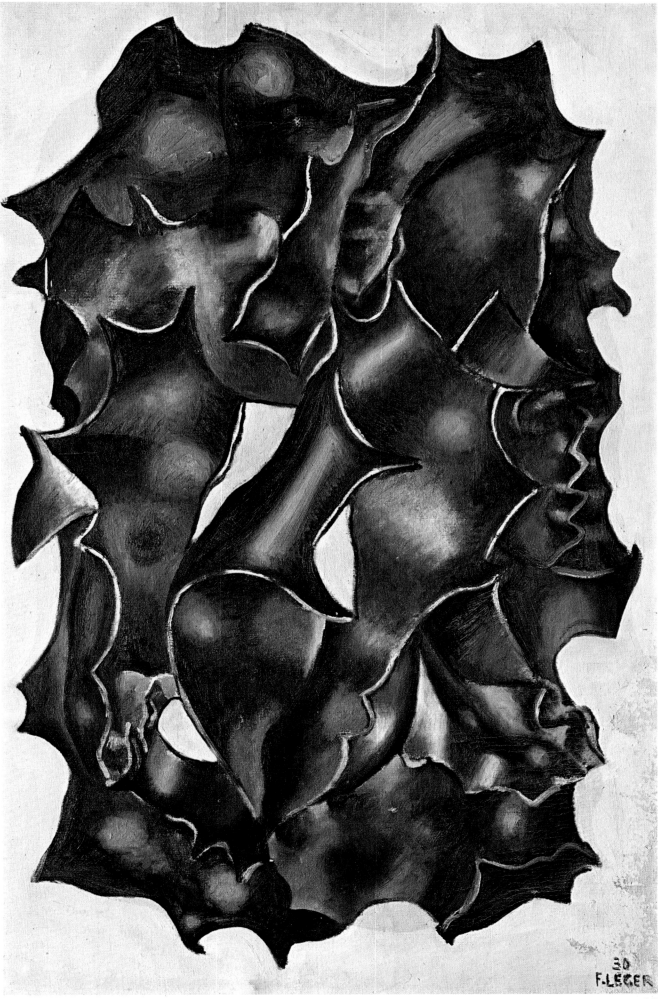

12

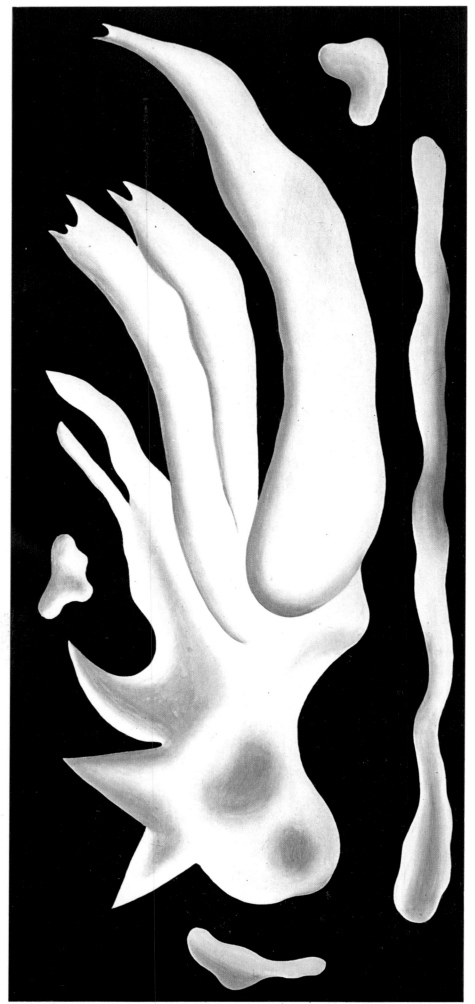

13

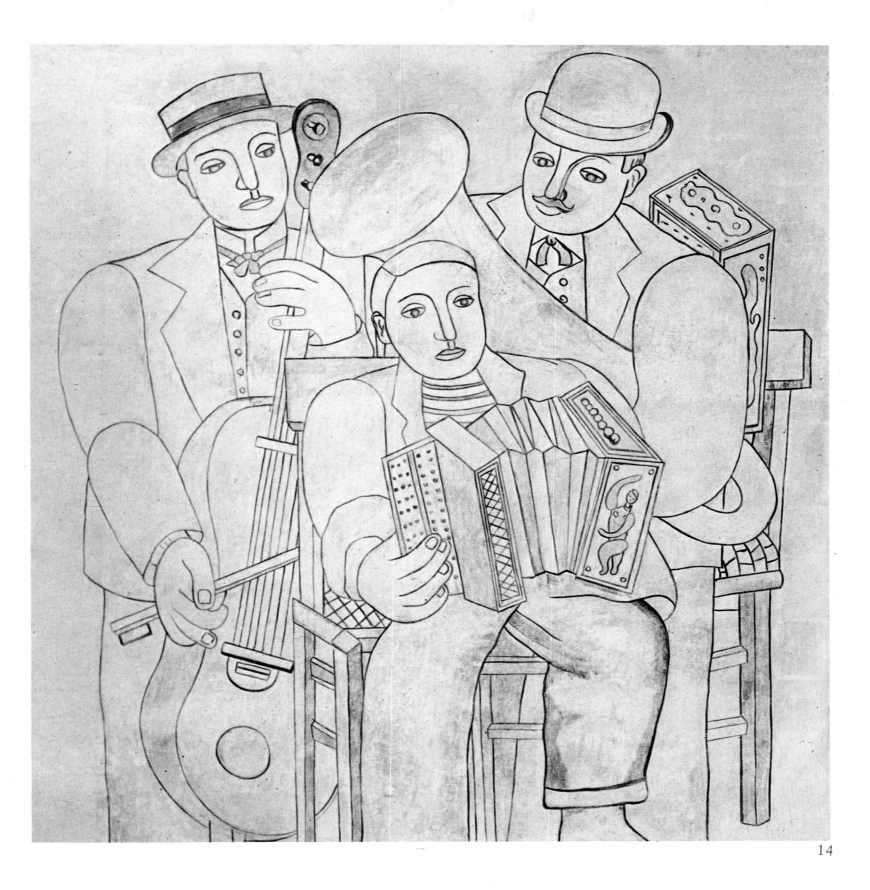

14

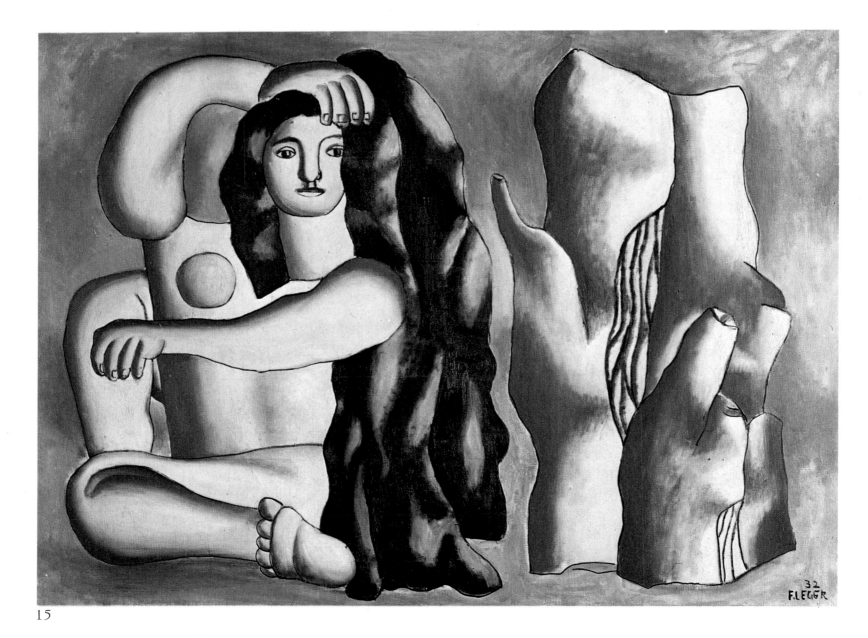

15

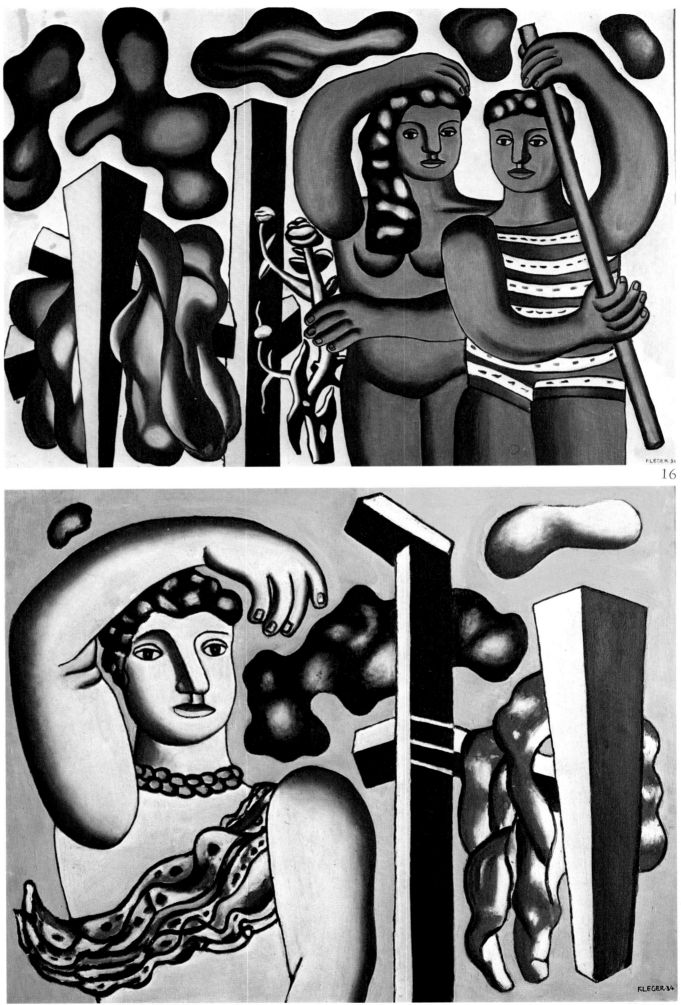

16

17

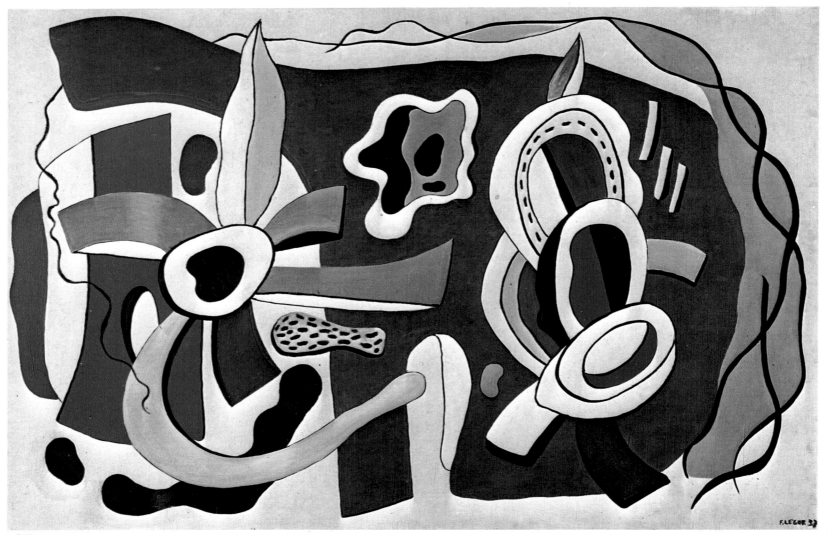

18

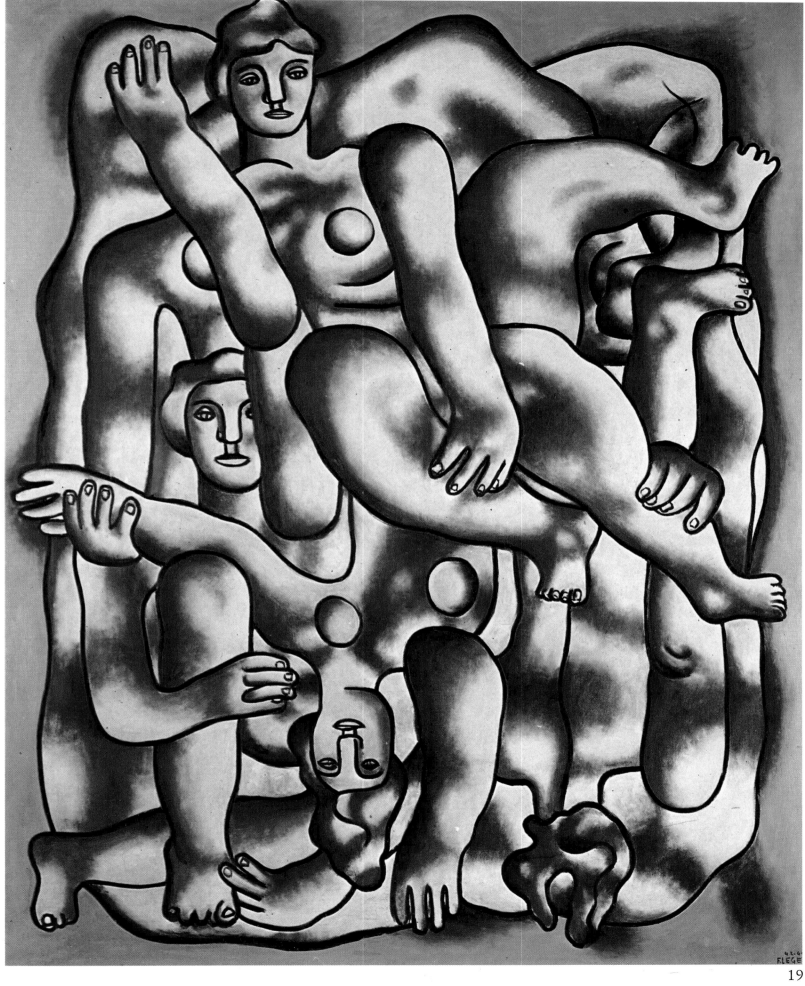

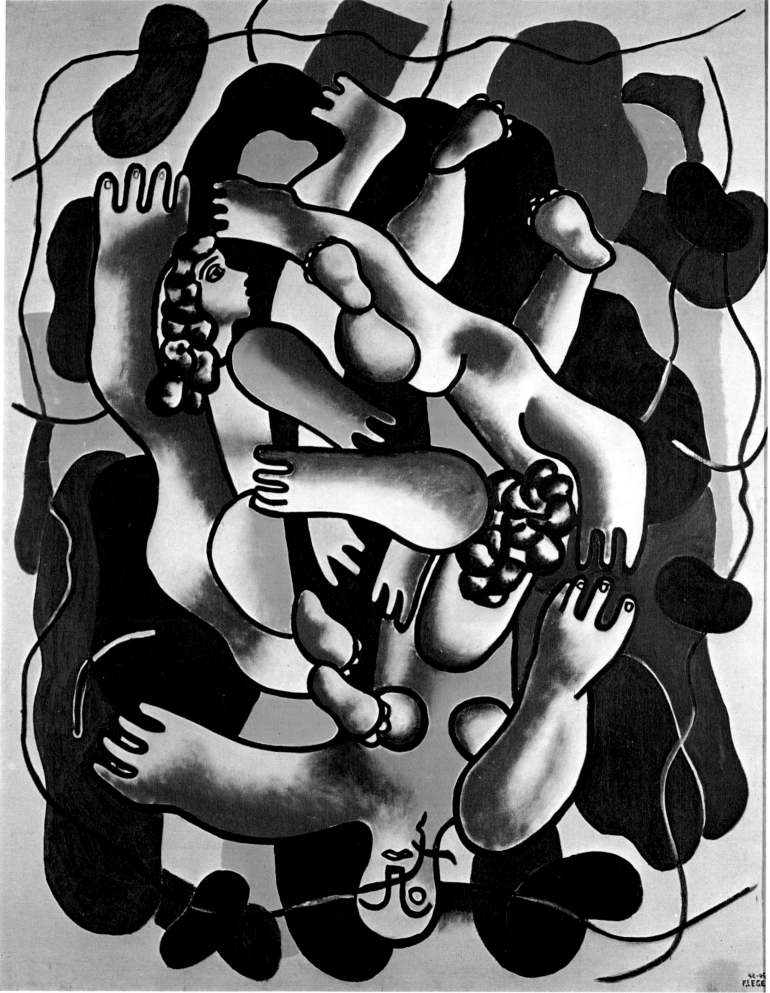

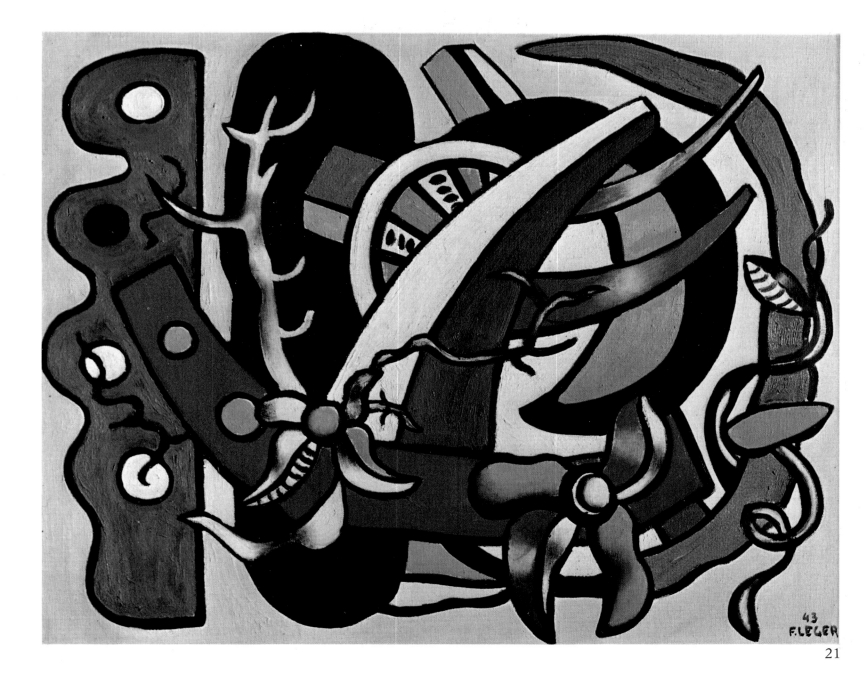

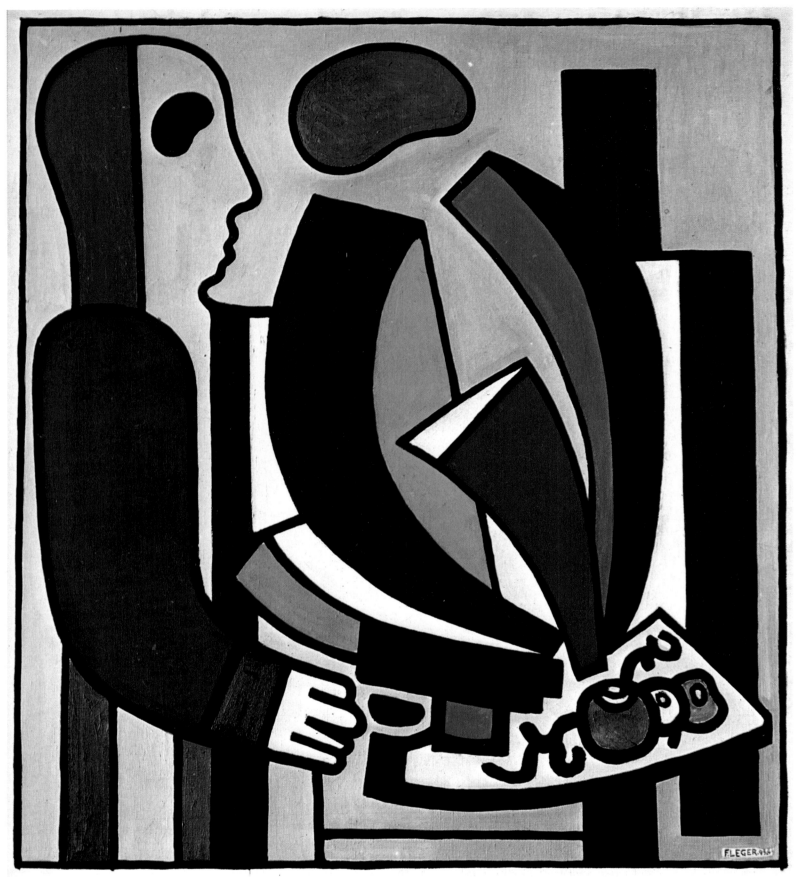

22

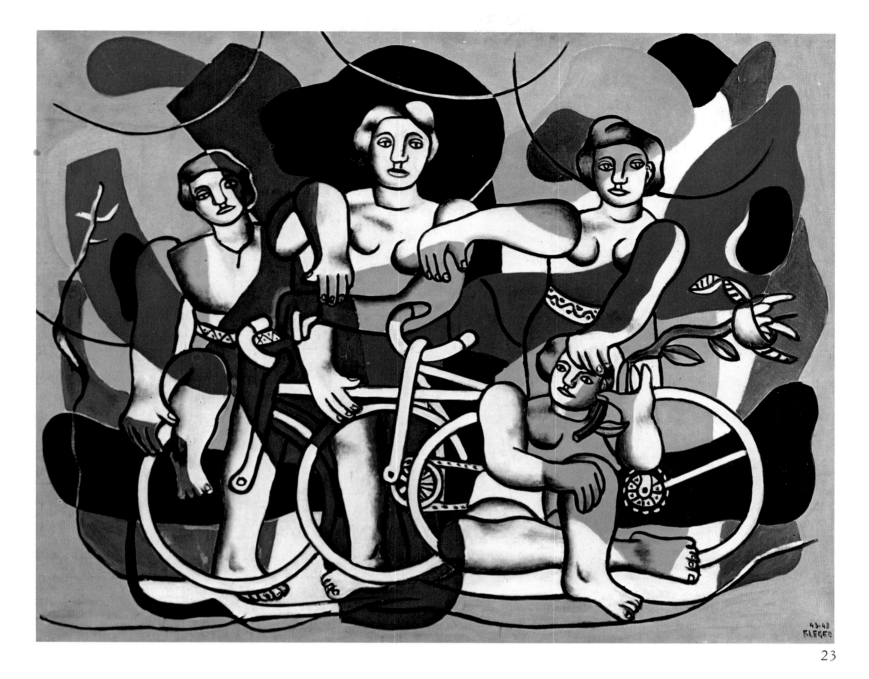

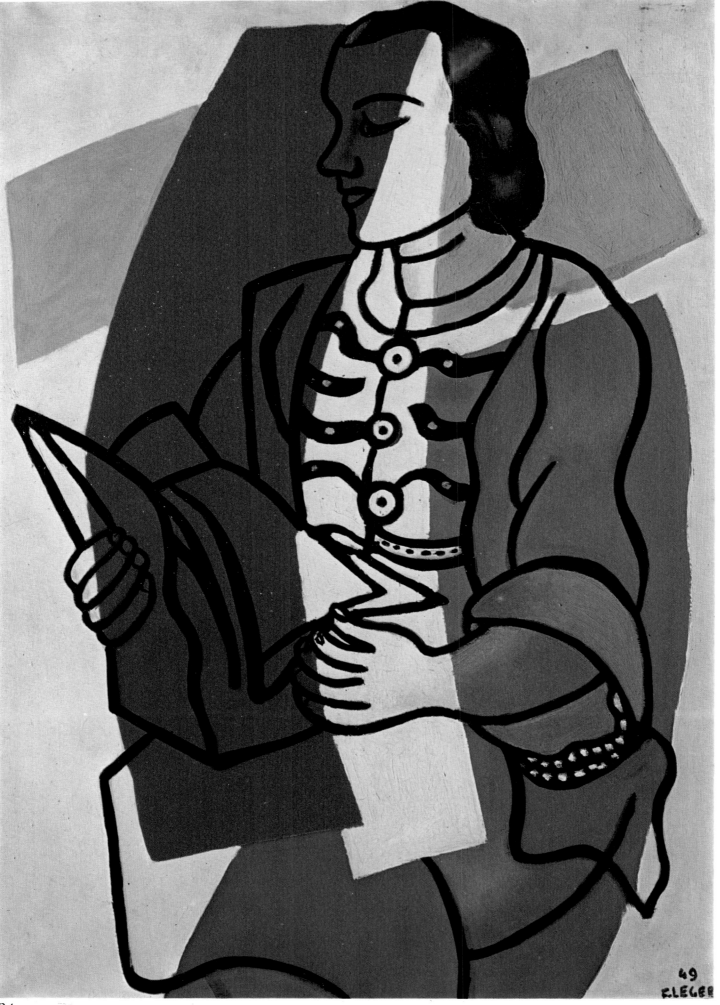

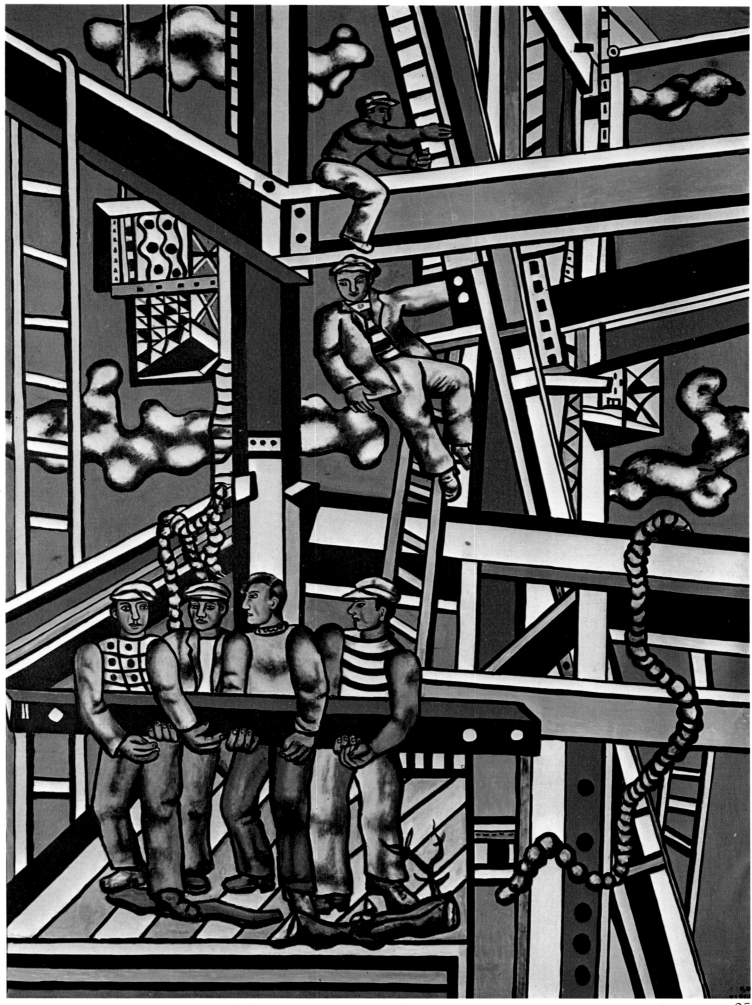

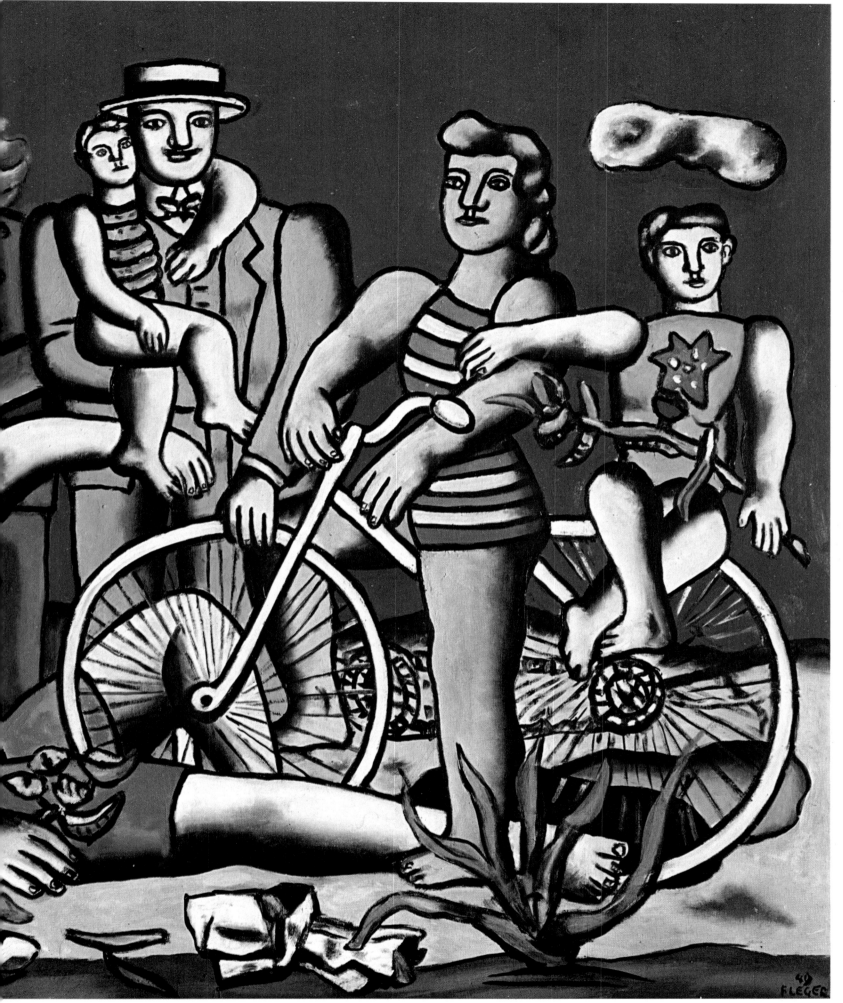

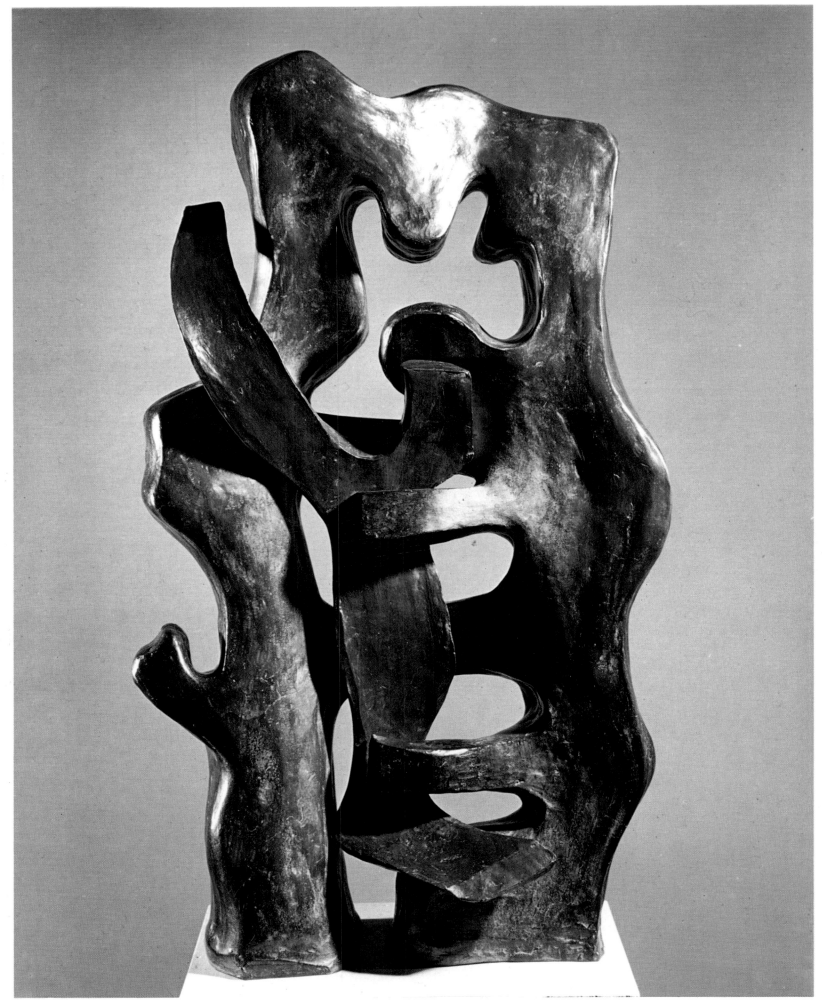

28

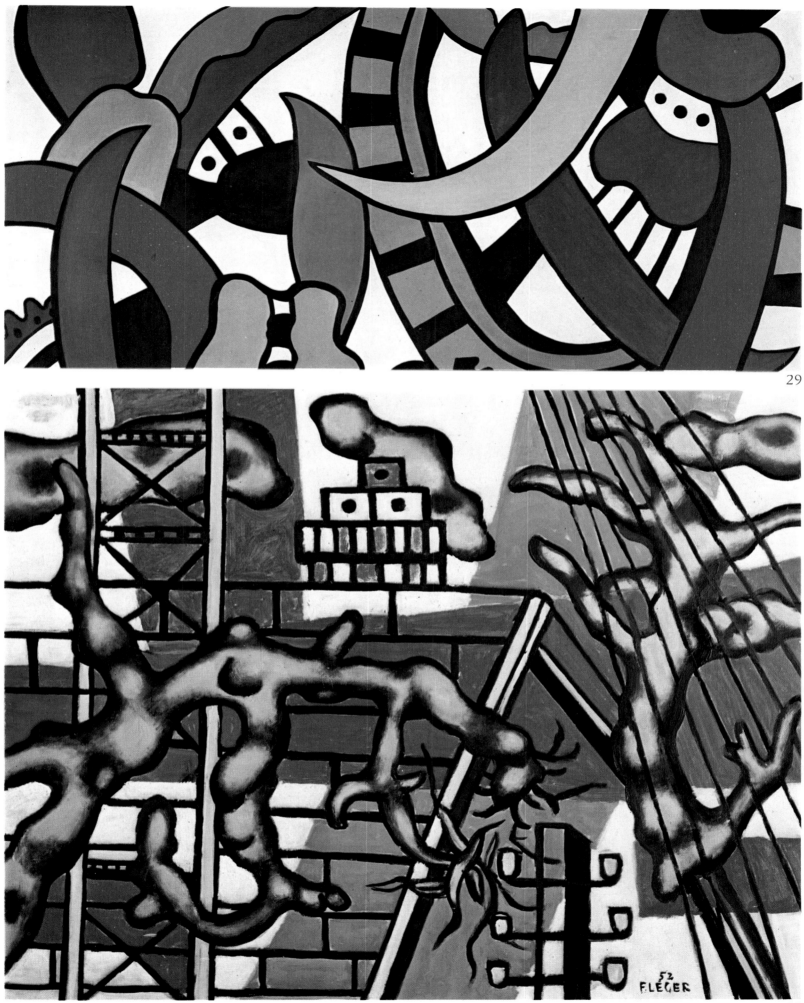

29

30

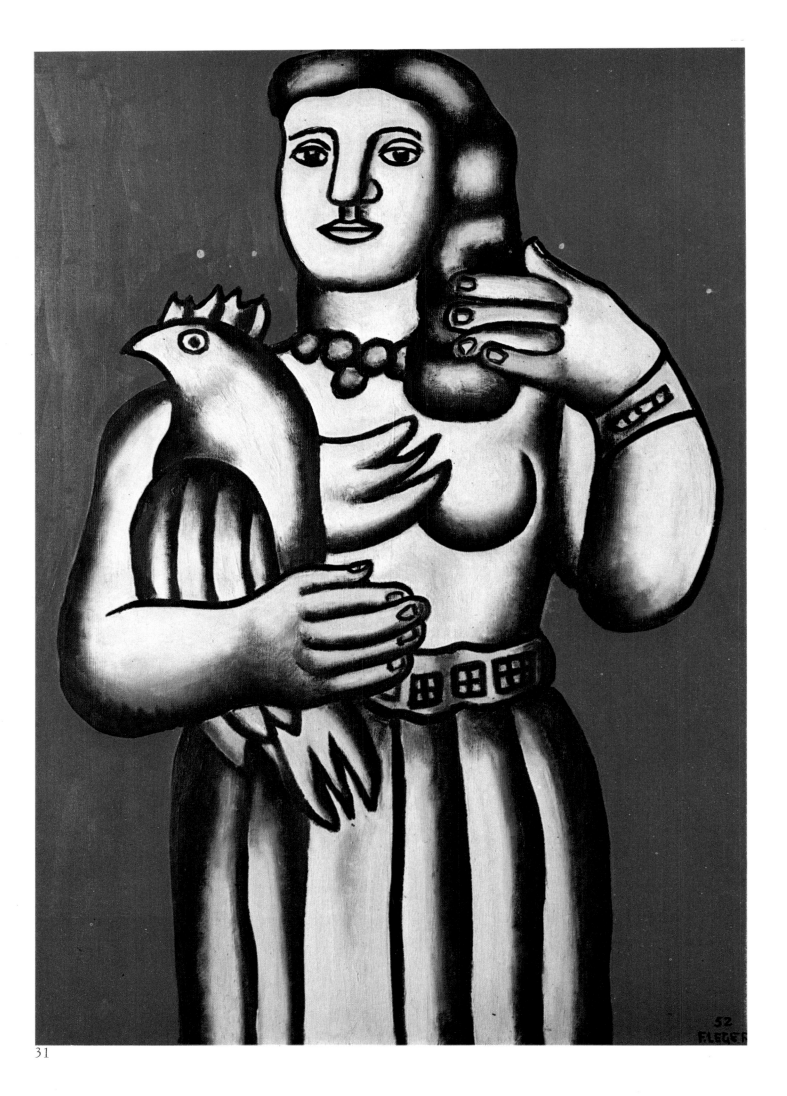

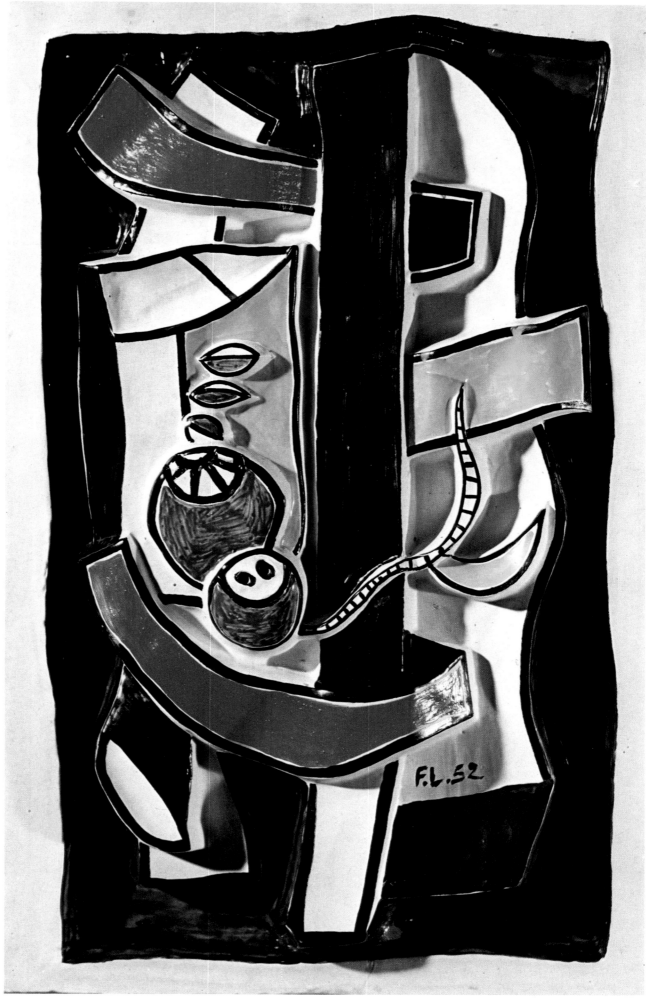

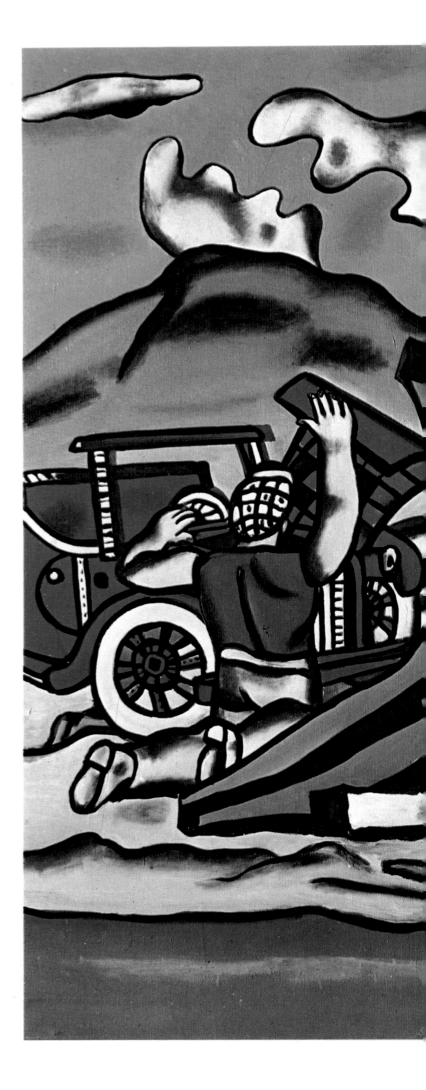

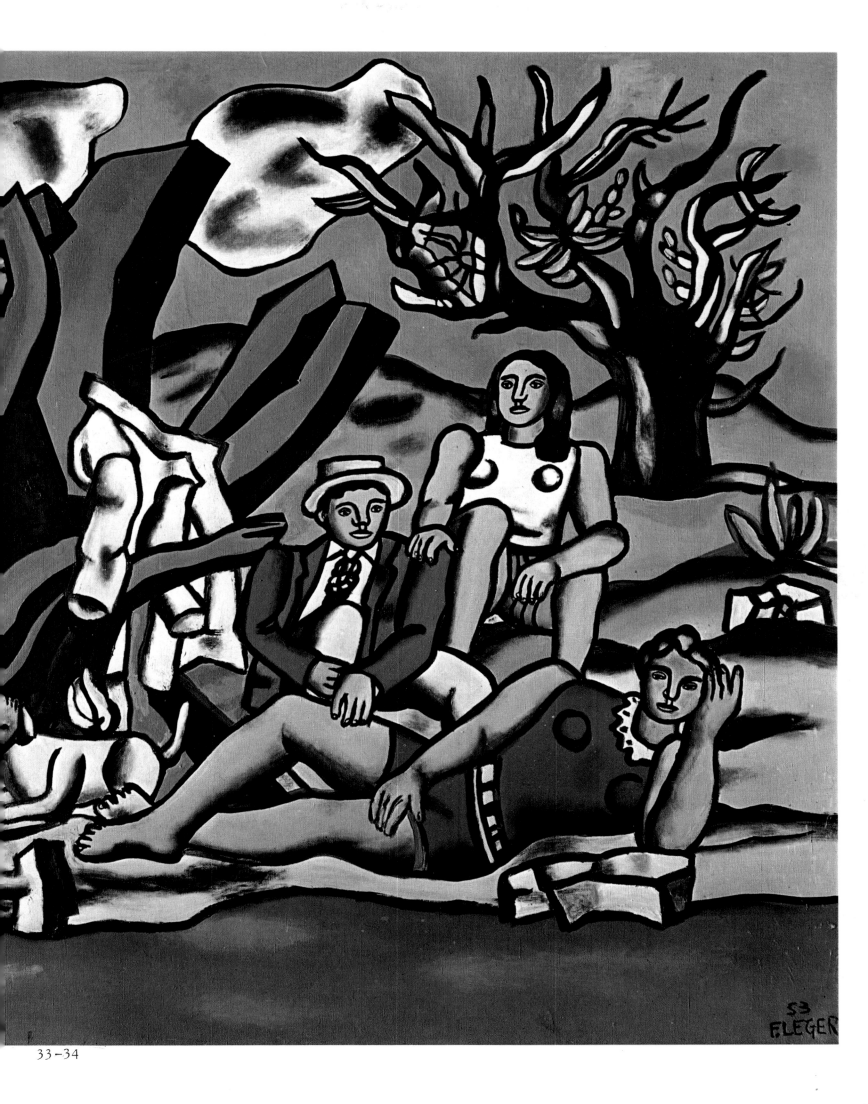

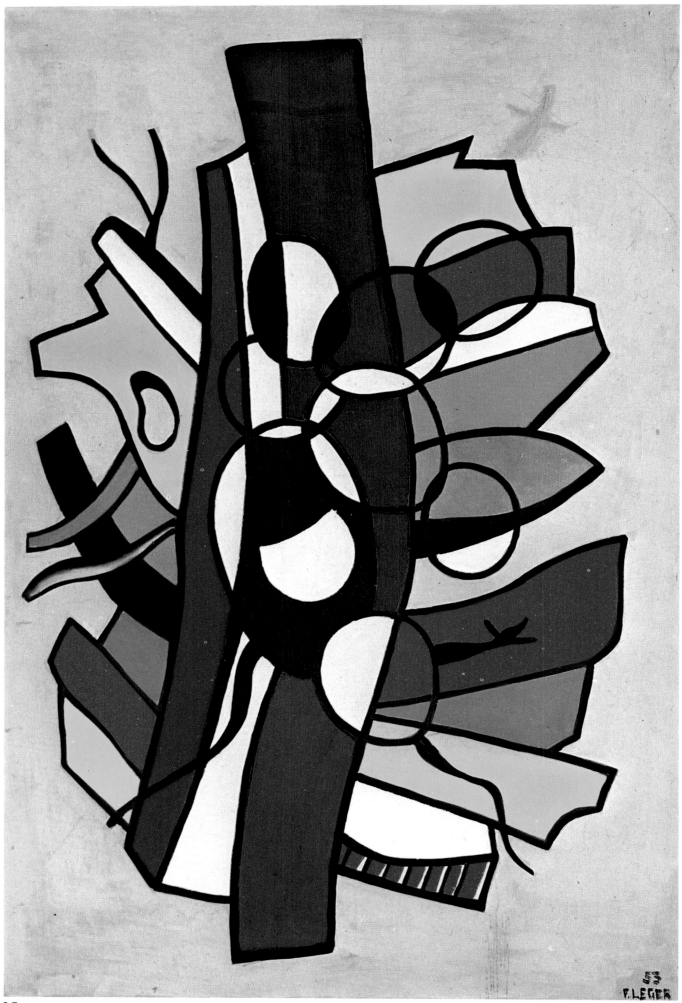

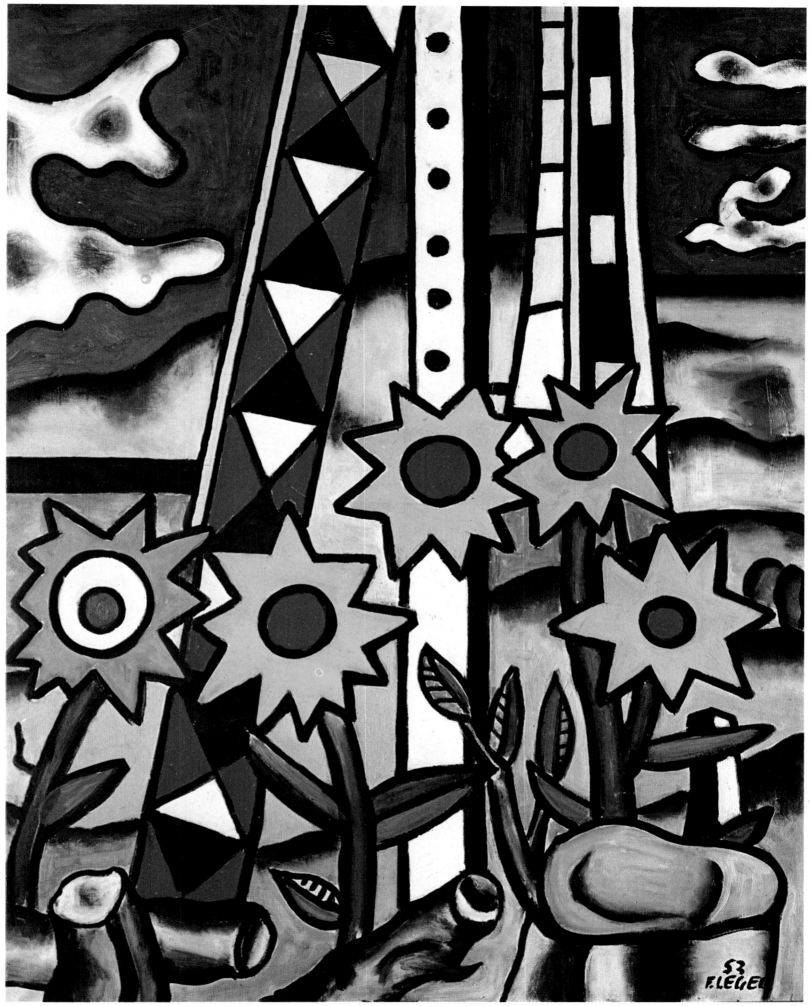

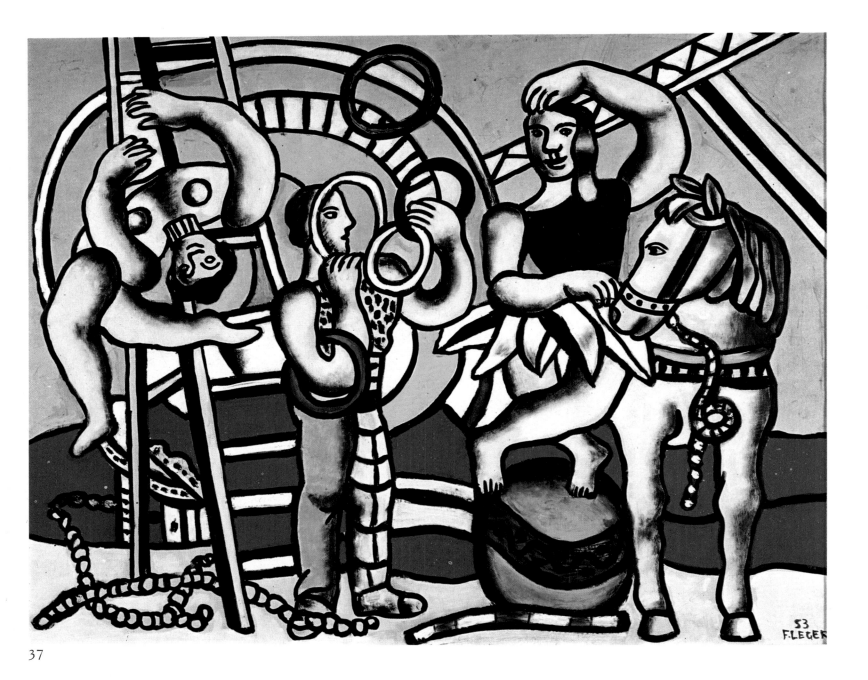

37

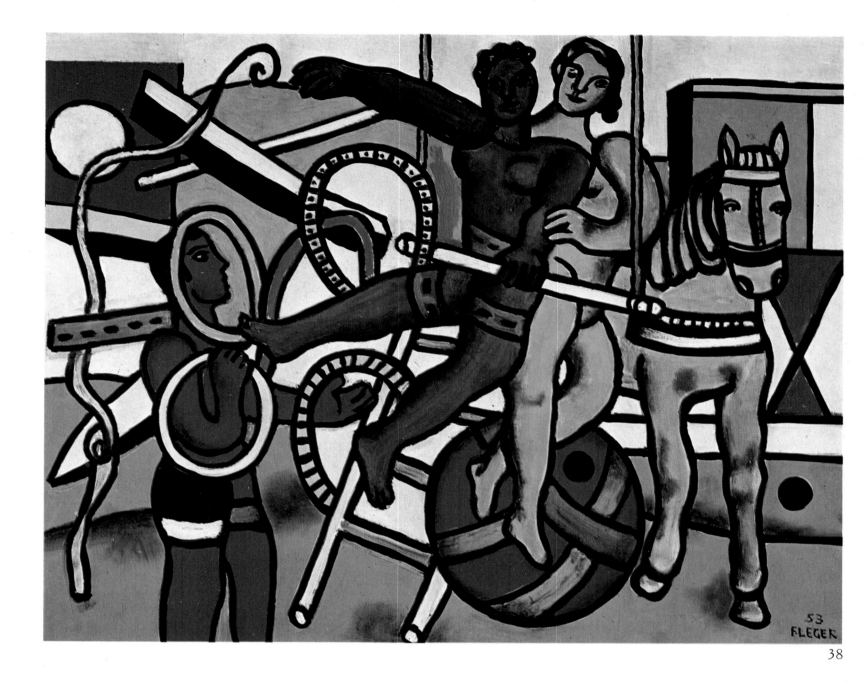

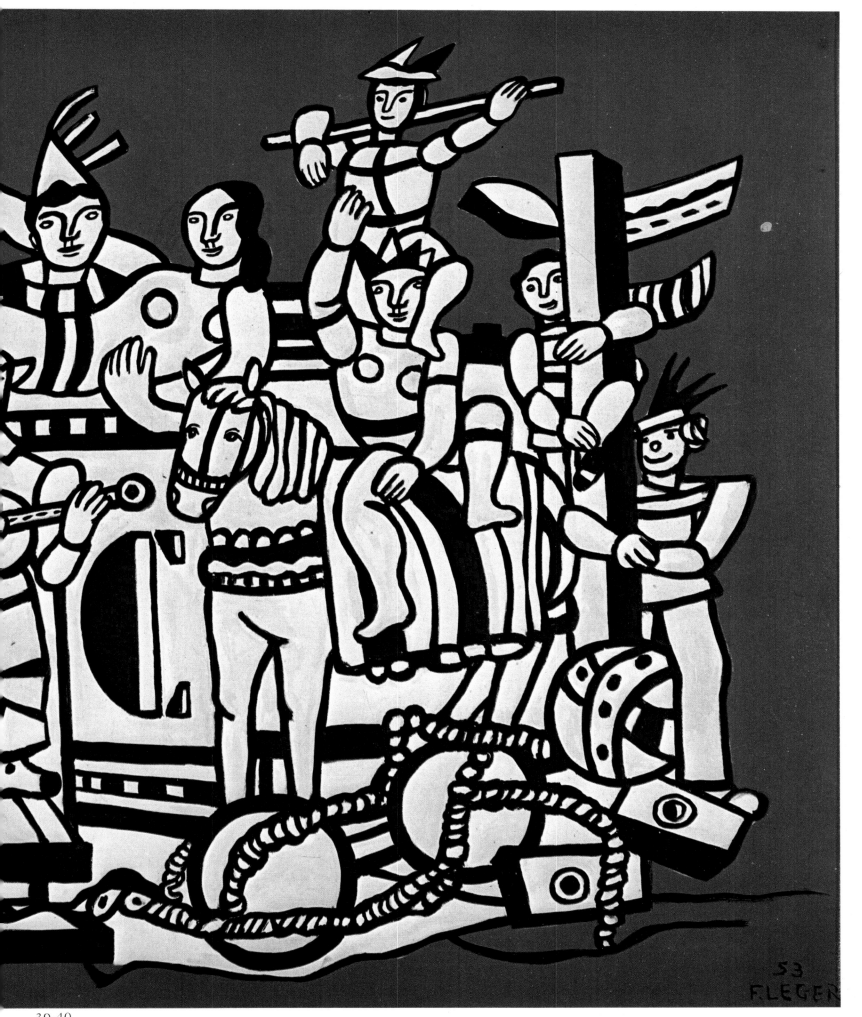

39-40

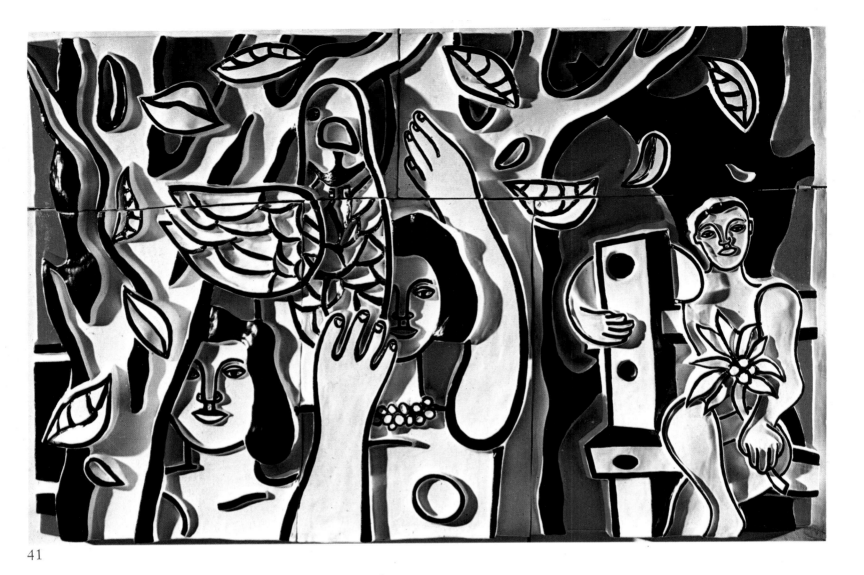

41

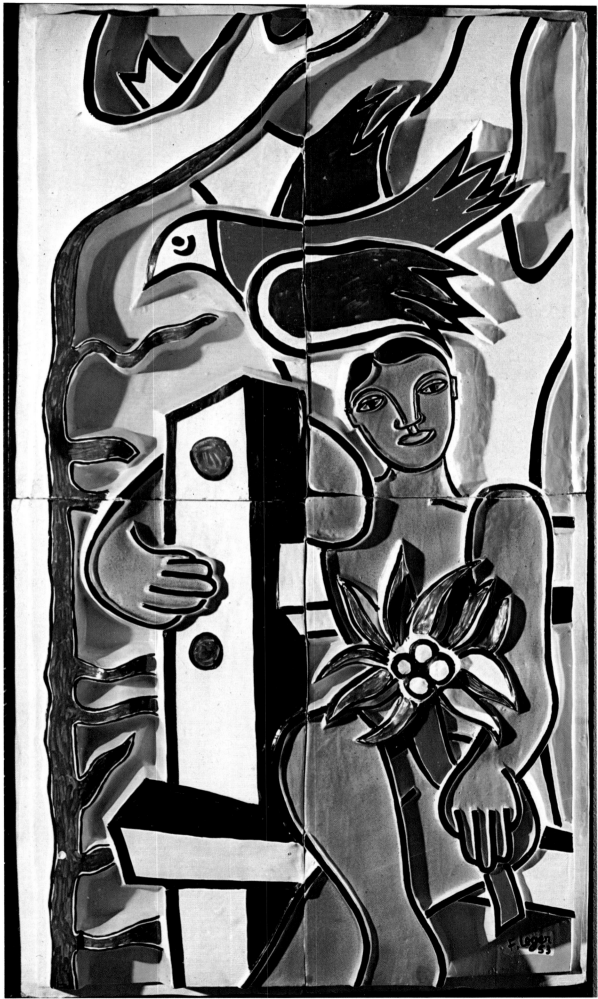

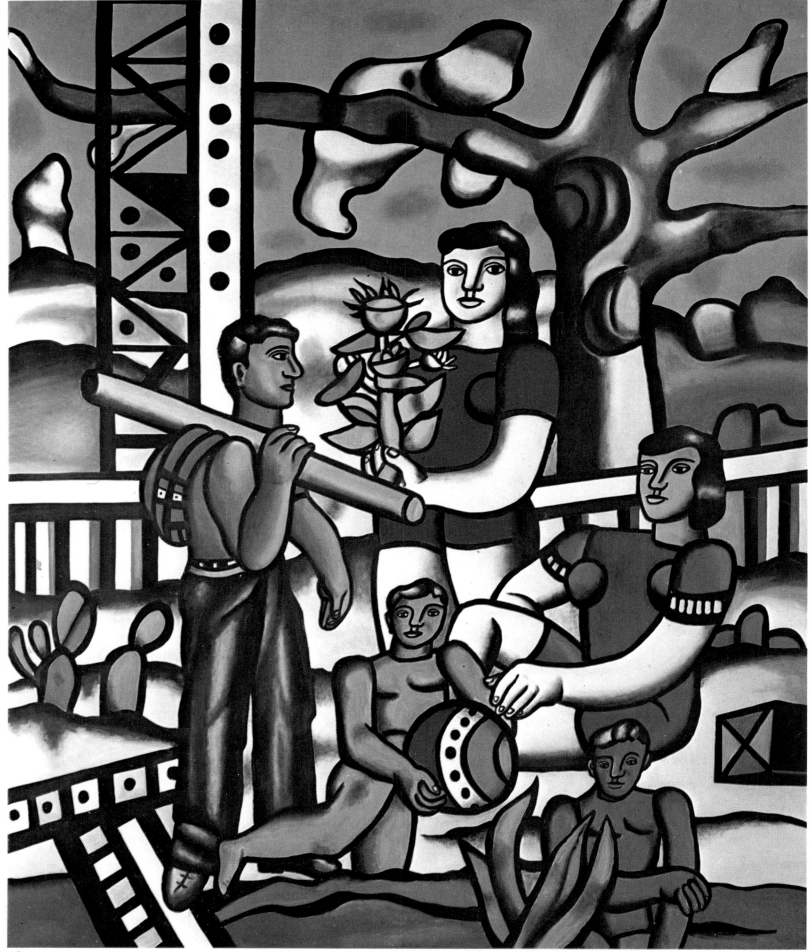

43

Description of colour plates

All the works reproduced in colour are in the collection of the Musée Léger at Biot.

1 *Portrait de mon oncle*
undated, oil on canvas

2 *Jardin de ma mère*
1905, oil on canvas

3 *La Femme en bleu*
1912, oil on canvas

4 *Contrastes de formes*
1913, oil on canvas

5 *14 Juillet*
1913, oil on canvas

6 *Femmes au bouquet*
1921, oil on canvas

7 *Le grand Remorqueur*
1923, oil on canvas

8 *Le Triangle jaune*
1926, oil on canvas

9 *Composition à la feuille*
1927, oil on canvas

10 *Le Profil noir*
1928, oil on canvas

11 *La Joconde aux clés*
1930, oil on canvas

12 *La Feuille de houx*
1930, oil on canvas

13 *Queue de comète*
1930, oil on canvas

14 *Les Musiciens*
c. 1930, drawing on canvas

15 *La Baigneuse*
1932, oil on canvas

16 *Adam et Eve*
1934, oil on canvas

17 *Marie l'acrobate*
1934, oil on canvas

18 *Composition à l'étoile sur fond bleu*
1937, oil on canvas

19 *Les Acrobates*
1942–6, oil on canvas

20 *Les Plongeurs*
1942–6, oil on canvas

21 *Les Fleurs dans les éléments mécaniques*
1943, oil on canvas

22 *L'Homme au melon*
1943–4, oil on canvas

23 *Les belles Cyclistes*
1943–8, oil on canvas

24 *Femme lisant*
1949, oil on canvas

25 *Les Constructeurs*
1950, oil on canvas

26–27 *Les Loisirs*
1949, oil on canvas

28 *La Branche*
1952, sculpture

29 Mural painting for the Vulcania
1952

30 *La Maison jaune et l'arbre vert*
1952, oil on canvas

31 *La Femme à l'oiseau*
1952, oil on canvas

32 *Composition*
1952, polychrome sculpture

33–34 *La Partie de campagne*
1953, oil on canvas

35 *Formes dans l'éspace*
1953, oil on canvas

36 *Les cinq Tournesols*
1953, oil on canvas

37 *L'Ecuyère noire*
1953, oil on canvas

38 *Le Jongleur et les deux trapézistes*
1953, oil on canvas

39–40 *La grande Parade sur fond rouge*
1953, oil on canvas

41 *Femmes au perroquet*
1953, polychrome sculpture

42 *Composition au perroquet*
1953, polychrome sculpture

43 *Le Campeur*
1954, oil on canvas

Biographical outline

1881. 4th February. Jules Fernand Henri Léger is born at Argentan, the son of Henri Armand and Marie Adèle Dauneu.

1897–9. Apprentice in an architect's studio at Caen.

1900–2. Paris–draughtsman in an architect's office.

1902–3. Versailles–military service in the Engineers.

1903. Admitted to the Ecole des Arts Décoratifs, having failed to get into the Ecole des Beaux-Arts. 'Elève-libre' at the studios of Léon Gerome and Gabriel Ferrier. Frequents the Académie Julian and the Louvre.

1903–4. He makes a difficult and precarious living employed in an architect's office and as a photographic retoucher. Shares a studio with his friend André Mare, also from Argentan, first in the rue Sainte-Place and then at 21, avenue du Maine.

1906–7. Ill–spends the winter in Corsica, at Belgelede on the Ile Rousse, with his friend Viel.

1907. Cézanne retrospective at the Salon d'Automne. 'Personally it has taken me three years to rid myself of the influence of Cézanne... the task was so difficult that to achieve it I had to go all the way to abstraction...'

1908–9. After three successive visits to Corsica in 1907 and 1908 returns to Paris and takes a studio in *La Ruche*, 2, Passage de Danzig, near the Vaugirard slaughter-houses, and the picturesque artists' community known as the *zone*, where Laurens, Archipenko, and Lipchitz, and later R. Delaunay, Chagall, and Soutine lived; and where Max Jacob, Reverdy, Apollinaire, Maurice Raynal and Léger's old friend Blaise Cendrars, were familiar figures.

1909. Paints *La Coseuse*. Meets Delaunay and Henri Rousseau; but a small canvas painted at Fontainebleau in July still retains an Impressionist structure.

1910. D. H. Kahnweiler discovers Léger and welcomes him to his gallery at 28, rue Vignon, where Braque and Picasso already show their work. Paints *Les Noces*. Moves first to 14, avenue du Maine and then to 13, rue de l'Ancienne-Comédie. Series of 'Roofs' painted from his window. With Delaunay, Gleizes, Le Fauconnier, A. Mare, Marie Laurencin, Kupka and Metzinger, Léger takes part in the gatherings at Jacques Villon's which were to lead to the formation of the Section d'Or Group.

1911. Paints *Les Fumeurs*.

1912. Exhibits *La Femme en bleu* at the 10th Salon d'Automne.

1913. D. H. Kahnweiler, who had already bought up all the canvases in his studio, offers Léger his first contract.

1914. Léger is mobilised and joins the Engineers, seeing active service first in the Argonne (1914–16) and later at Verdun, as a stretcher-bearer. (1916–17). Makes numerous drawings in the trenches and in camp, which he would use as studios for future paintings.

1917. Paints *Soldats jouant aux cartes*. By now Léger has completely broken away from Impressionism. He considers himself the witness of a new civilisation, devoted to speed and to the machine, and creates a dynamic world of levers, cog-wheels and engines. But unlike the Italian Futurists, who tend towards a 'futuristic romanticism', or the Dutch artists of Neo-Plasticism (van Doesburg, Mondrian), who allow themselves to be seduced by the exact, aristocratic, disembodied beauty of the machine, Léger is fascinated by its extraordinary power.

1918. Paints *Les Disques*. Illustrates *J'ai tué* by Blaise Cendrars.

1919. *Paints La Ville*. Illustrates *La Fin du Monde filmée par l'ange Notre Dame,* by Blaise Cendrars. On December 2nd marries Jeanne Augustine Adrienne Lohy.

1920. Foundation of 'L'Esprit Nouveau'. Meeting with Le Corbusier. The figure, which had practically disappeared from Léger's previous works (man is a robot in capitalist society), gradually regains its place, at first discretely, bereft of any psychological meaning, later becoming more and more clearly the real subject ('le grand sujet'), object, and pretext of contrasts with the geometry of the other elements of the composition: table, floor, window. Animated landscapes, static figures, classically inspired, immobile; full volumes, pure colours. Paints *Le Mécanicien* and *Le Grand déjeuner*.

1921. Paints *La Mère et l'enfant*. Works with Blaise Cendrars on Abel Gance's film *La Roue*. Illustrates André Malraux's '*Lunes en papier*'. Designs scenery for *Skating Rink* by the Ballet Suédois, with music by Honegger.

1922. Does sets and costumes for Ralf de Mare's ballet *La Création du Monde*, with music by Darius Milhaud, libretto by Blaise Cendrars. The search for a monumental effect leads Léger to study the function of the object, which he isolates, enormously enlarged, in its surroundings, associating it, in his continual search for contrasts, with the most unexpected elements. This discovery of the object in space, which he then developed a language to explain, is the starting point of Léger's personal experiments in the cinema, which helped to define his visual sense just as photography had influenced Degas and Toulouse-Lautrec.

1923. Marcel L'Herbier's film *L'Inhumaine* with scenery by R. Mallet-Stevens, H. Cavalcanti, photography by Autant-Lara, and music by Darius Milhaud (produced by Cinégraphic).

1924. Léger makes *Le Ballet Mécanique,* the first film without a scenario. Photography by Man Ray and Dudley Murphy, music by G. Antheil. Goes to Italy with Leonce Rosenberg: visits Ravenna. Founds a free studio with Ozenfant, at 86, rue Notre-Dame-des-Champs, where he teaches, together with Marie Laurencin and Exter.

1925. Léger and Delaunay decorate the entrance hall of the 'French Embassy' Pavilion, designed by R. Mallet-Stevens, at the Exhibition of Decorative Art. Léger does his first mural paintings for Corbusier's pavilion of 'l'Esprit Nouveau'.

1926. Exhibition at the Galerie des Quatre-Chemins.

1927. Paints *Profils, chapeaux, bouteilles* and *Le Roi de cartes*.

1928. Visits Berlin for his exhibition at the Alfred Flechtheim Gallery. As a reaction to his recent static experiments Léger concentrates on the representation of scattered objects, at first linked with architectural elements, and later autonomous, playing on their different relations and compositional rhythms. The desire for contrasts which never ceased to animate him, led him to juxtapose the most heterogenious objects: the points of a compass with the curve of an apple; a bunch of keys with a copy of the Mona Lisa; a coin and a garland of flowers. His intention in combining such objects was in no way surrealist, but that each should enhance the values of the other.

1930. Paints *La Joconde aux clés*.

1931. Spends July and August with Gerald Murphy at Bedensee in Austria. Makes his first trip to the United States, where he stays from September to December, in New York and Chicago.

1932. Becomes a professor at the Grande-Chaumière.

1933. Goes to Zurich in April for his exhibition at the Kunsthaus. Visits Greece in August with Le Corbusier for the congress of the C.I.A.M. On his return gives a lecture on *L'Architecture devant la vie* on board the Patris II.

1934. Spends July at Antibes as the guest of Gerald Murphy. Goes to London in August with Simone Herman. Works for Alexander Korda on the scenery for the film of H. G. Wells' *The Shape of Things to Come*. Goes to Stockholm for his exhibition at the Modern Gallery in September. Göteborg Museum buys *La Femme à la toilette*.

1935. July. Goes to Brussels with Charlotte Perriand. Decorates the hall of the International Exhibition of Fine Arts in Brussels. Second visit to the United States, where he meets Le Corbusier again, with Simone Herman. Léger's first exhibition at the Museum of Modern Art in New York. Exhibition at the Art Institute of Chicago. In the course of this visit Léger gets to know a number of American intellectuals, including James J. Sweeney, J. Dos Passos and the architect Kisler.

1935–9. Paints *Adam et Eve* and *Composition aux perroquets*.

1937. Paints scenery for the ballet *David triomphant* by Serge Lifar, music by Rieti, at the Paris Opera. Designs the decorations for the C.G.T. celebrations at the Vélodrome d'Hiver in Paris. Executes mural painting *Le Transport des forces* for the Palais de la Découverte. Gives a lecture in Antwerp in November on *La Couleur dans le Monde*. Makes a trip to Finland on the occasion of his exhibition in Helsinki.

1938. Third visit to the United States, from September to March the

following year. Decorates the apartment of Nelson A. Rockefeller Jr. in New York. He stays at Princeton as the guest of Dos Passos, and with the architect Harrison on Long Island.

1939. Designs the scenery for *Naissance d'une cité*, a play by J. R. Bloch, with music by Darius Milhaud and Arthur Honegger, at the Vélodrome d'Hiver in Paris.

1940. Escapes before the German advance to Lisores in Normandy, then to Bordeaux, and finally to Marseilles, where he embarks for the United States with Jacqueline Rey. Becomes a professor at Yale University, together with Henri Focillon, Darius Milhaud and André Maurois; holds courses at Mills College in California in the summer of 1941. Period of great activity: decorative projects for Radio-City, and Rockefeller Center; numerous pictures inspired by the *Intensité americaine* and the advertising realism of Broadway, full of animation and contrast.

1941. Paints the *Plongeurs sur fond jaune*.

1944. Paints *Les Belles cyclistes*.

1944–9. Paints *Les Loisirs* and *Hommage à David*.

1945. December, returns to France.

1946. Thomas Bouchard makes the film *Léger in America* with a commentary by Léger himself. Father Couturier commissions him to make a mosaic measuring 7×16 metres to decorate the façade of the church at Assy, in Haute Savoie; the mosaic was completed in 1949. Exhibition at the Galerie Louis Carré in Paris.

1948. *Dreams that Money can Buy*: director and producer Hans Ernst; objects and ideas: Alexander Calder, Marcel Duchamp, Max Ernst, Fernand Léger, Man Ray, Hans Richter. Mural decoration (carried out by the pupils of the Léger studio) for the Congrès International des Femmes, at the Porte de Versailles. Scenery for *Pas d'Acier,* music by Prokofiev, for the Ballets de Champs-Elysées. Trip to Poland. Peace Congress at Wroclaw.

1949. Retrospective exhibition (1905–49) at the Musée Nationale d'Art Moderne in Paris. Illustrations for Rimbaud's *Illuminations* (Grosclaude, Lausanne). Text and illustrations for *Le Cirque* (Teriade, Paris). Designs scenery and costumes for Darius Milhaud's four-act opera *Bolivar,* performed at the Paris Opera. Makes his first ceramics at Biot with his former pupil Roland Brice.

1950. Jeanne Léger dies. Léger paints *Les Constructeurs*. Executes the mosaics for the Bastogne Memorial in Belgium.

1951. Stained-glass windows and tapestries for the church at Audincourt. Travels in Italy. Settles at Chevreuse. Paints numerous landscapes of Seine-et-Oise.

1952. On the 21st February Léger marries Nadine Khodossievitch, who had come to France in 1924 to follow his teaching. Stays in Venice for the Biennale. Decorates the large hall of the U.N. building in New York. Settles at Gif-sur-Yvette, in Gros Tilleul.

1953. Illustrates *Liberté,* object-poem with a text by Paul Eluard (Seghers, Paris). Paints *La Partie de campagne* and *La Grande Parade sur fond rouge.*

1953–4. Makes stained-glass windows for the church at Courfaivre in Switzerland.

1954. Paints *La Grande Parade*. Stained-glass windows for the University of Caracas. Designs for a large mosaic decoration for the administrative building of Gaz de France at Altefortville. Projects for a mosaic decoration for the Auditorium of São Paulo in Brazil (architect Niemeyer).

1955. Trip to Czechoslovakia for the Sokols Congress at Prague. Exhibition at Lyons Museum. Exhibition at the third Biennale of São Paulo, Brazil: wins the Gran Premio of the Biennale. 17th August, Léger dies at Gif-sur-Yvette.

23 Fernand Léger in his studio

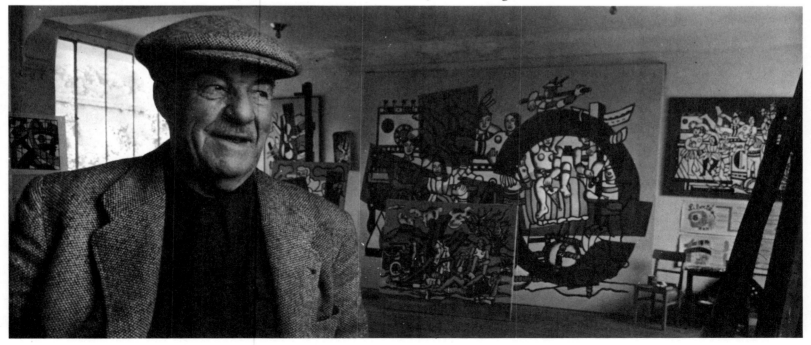

Exhibitions and catalogues

1908. *Pêcheurs corses*, Salon d'Automne, Paris.

1909. *Les Voiles rouges*, *Le Jardin*, Salon d'Automne, Paris.

1910. *Dessin*, Salon d'Automne, Paris.

1911. *Essai pour trois portraits*, Salon d'Automne, Paris; *La Femme couchée, Etude, Nature morte, Nature morte, Etude*, Salon des Indépendants, Paris.

1912. Galerie Kahnweiler, Paris; Section d'or, Paris; *La Femme en bleu*, Salon d'Automne, Paris.

1913. Der Sturm Gallery, Berlin; Armory Show, New York, Chicago, Boston; Section d'or, Paris.

1919. Galerie de l'Effort Moderne, Paris; Galerie Selection, Antwerp.

1920. *La Ville, Les Disques dans la Ville*, Salon des Indépendants, Paris.

1921. *La Femme couchée, La Femme et l'Enfant, Les deux Femmes et la nature morte*, Salon des Indépendants, Paris; Hôtel Drouot, Paris, first and second Kahnweiler sales (7 and 13 canvases).

1922. Hôtel Drouot, Paris, third Kahnweiler sale (8 canvases).

1923. Hôtel Drouot, Paris, fourth Kahnweiler sale (18 canvases, 204 drawings).

1925. Anderson Galleries, New York–*Catalogue* by Carl Einstein with notes by F.L.

1926. Brooklyn Museum, New York; Galerie des Quatre-Chemins, Paris; *30 years in retrospect, 1884–1914, Paysage 1906, Les Fumeurs 1911, Paysage 1913, La Ville 1918–19, Eléments mécaniques 1923, Nature morte*, Salon des Indépendants, Paris.

1928. 100 works, Alfred Flechtheim Gallery, Berlin–*Catalogue* by A. Flechtheim with notes by F.L.; Galerie de l'Effort Moderne, Paris.

1930. Leicester Galleries, London (with Metzinger and Severini); Galerie Rosenberg, Paris.

1931. 42 works, John Becker Gallery, New York; Durand-Ruel Galleries Paris; Museum of French Art, Paris (with Picasso and Braque).

1932. Valentine Gallery, New York.

1933. Kunsthaus, Zurich.

1934. Galerie Vignon, Paris; Gallery of Modern Art, Stockholm.

1935. 31 works, Art Institute of Chicago; 43 works, Museum of Modern Art, New York; *Les Créateurs du Cubisme*, Beaux-Arts and Gazette des Beaux-Arts, Paris–*Catalogue* by Raymond Cogniat; Hôtel Drouot, Zoubaloff sale (18 works).

1936. *Cubism and Abstract art*, Museum of Modern Art, New York–*Catalogue* by Alfred H. Barr Jr.

1937. Astek Gallery, Helsinki; London Gallery, London; *Les Maîtres de l'Art indépendant*, Petit Palais, Paris; Galerie Rosenberg, Paris.

1938. 72 works, Palais des Beaux-Arts, Brussels; Mayor Gallery, London; Rosenberg and Helft Gallery, New York; Pierre Matisse Gallery, New York.

1939. Kestnergesellschaft, Hannover (with A. Masson and Waty Werner).

1940. 30 works, Katharine Kuh Gallery, Chicago; Nierendorf Galleries, New York; Galerie Mai, Paris.

1941. Arts Club, Chicago–*Catalogue* by J. J. Sweeney; Stendhall Gallery, Los Angeles; Mills College Art Gallery, Oakland; *Alexander Calder: Mobiles, Jewelry; Fernand Léger: Gouaches, Drawings*, Arts and Crafts Club, New Orleans; Marie Harriman Gallery, New York; *Chrysler Collection*: 31 works, Museum of Fine Arts, Richmond.

1942. Buchholz Gallery-Curt Valentin, Rosenberg Gallery, Valentine Gallery, New York.

1943. Dominion Gallery, Montreal.

1945. Fogg Art Museum, Cambridge; Samuel M. Kootz Gallery, Valentine Gallery, New York; 22 works before 1940, Galerie Louis Carré, Paris; *Le Cubisme 1911–18* Gallery de France, Critical note by André Lothe; Gallery Collection: Picasso, Léger, Philadelphia Museum.

1946. 19 works 1940–45, Galerie Louis Carré, Paris.

1947. *Alexander Calder, Fernand Léger: Les Constructeurs*, Stedelijk Museum, Amsterdam; *Peintures et sculptures contemporaines*, Palais des Papes, Avignon; Kunsthalle, Berne (with Calder, Bodmer, Leuppi); *Les Maîtres de la Peinture française contemporaine*, Landesamt für Museen, Friburg; *The cubist spirit in its time*, London Gallery, London; Nierendorf Galleries, New York; Galerie Nina Dannset, Paris (with Helion and Masson).

1948. Sidney Janis Gallery, New York; 30 paintings, Galerie Louis Carré, Paris; *Retrospectiv Utstallning F. Léger*, Svensk-Franska Konstgalleriet, Stockholm–*Catalogue* by Folk Holmer; 71 works, Salon de l'Art Mural, Palais des Papes, Avignon.

1949. Landesamt für Museen, Fribourg–*Catalogue* by Willi Baumeister; *Fernand Léger, exposition rétrospective 1905–49:* 90 works, Musée National d'Art Moderne, Paris–*Catalogue*, by Jean Cassou; *L'Art Abstrait*, Galerie Maeght, Paris.

1950. 76 works, Tate Gallery, London–*Catalogue* by Douglas Cooper; Buchholz Gallery-Curt Valentin, New York; *The Artist in the Machine Age*, Louis Carré Gallery, Paris; *Art Sacré*, Musée National d'Art Moderne, Paris; Lithographes by Léger for *Le Cirque*, Gallery 16, Zurich; *Quattro Maestri del Cubismo*, XXV Venice Biennale.

1951. *70th Anniversary Exhibition, Léger*, Louis Carré Gallery, New York–*Catalogue* by M. A. Couturier, A. Ozenfant, G. L. K. Morris, C. Zervos, A. H. Barr Jr., E. Teriade, J. J. Sweeney, M. Raynal, S. Giedion, D. Cooper, Le Corbusier, W. Baumeister, D. Sutton; *Early Léger, Oil Paintings 1911–25*, Sidney Janis Gallery, New York; *Léger and Picasso*, Saidenberg Gallery, New York; 48 works, Kunstnerforbundet, Oslo; 68 polychrome sculptures and lithographs, Galerie Louise Leiris, Paris; *Sur quatre murs*, Galerie Maeght, Paris; *Les Constructeurs*, Maison de la Pensée Française, Paris.

1952. Musée, Antibes; Stedelijk Museum, Amsterdam; *Werke Französischer Meister der Gegenwart*, Hochschule für Bildende Künste, Berline–*Catalogue* by J. Tiburtius, M. Jardot, A. Jamasch, D.-H. Kahnweiler; 118 works, Kunsthalle, Berne–*Catalogue* by M. Raynal; Art Institute of Chicago; Sidney Janis Gallery, New York; Perls Galleries, New York; *59 ans de peinture française dans les collections particulières*, Musée des Arts Décoratifs, Paris; *La figure dans l'Oeuvre de Léger*, Galerie Louis Carré, Paris–*Catalogue* by A. Maurois and F. Léger; XXVI Venice Biennale.

1953. Art Institute of Chicago; *The Second International Travelling Art Exhibition*, Japan; Museum of Modern Art, New York; Saidenberg Gallery, New York; Musée National d'Art Moderne, Paris; *Un siècle d'art français*, Petit Palais, Paris; *F.L. Sculptures Polychromes*, Galerie Louis Carré, Paris, F.L. *Vers l'Architecture*; 23 paintings, Museum of Art, San Francisco; *Pittori d'oggi*, Palazzo delle Arti, Turin.

1955. Sidney Janis Gallery, New York; Maison de la Pensée Française, Paris–*Catalogue* by G. Huisamn; Petit Palais, *Le paysage dans l'oeuvre de Léger*, 26 paintings, Galerie Louis Carré, Paris; *Cézanne to Picasso* Liljevalchs Konsthall, Stockholm; *Exposition du groupe Espace*, Biot–*Catalogue* by André Block; *Kunst des XX Jahrhunderts?* Museum Friedericianum-Documenta, Kassel; Städisches Museum Leverkusen–*Catalogue* by C. Schwercher; Marlborough Fine Arts Ltd., London–*Catalogue* by M. Jardot; 95 canvases, Musée des Beaux-Arts, Lyon; *Hommage à Léger*, Galerie Maeght, Paris–*Catalogue* by P. Reverdy; Museo d'Arte Moderna, Rio de Janeiro; Gallery Wurthle, Vienna (with Gromaire, Villon Kupka).

Since Léger's death the principal exhibitions of his work have been held at Amsterdam, Paris (1956); Eindhoven, Munich, Basle, Zurich, Dotmund, Turin (1957); New York, Paris (1958); Stockholm, Vallauris (1959); Paris, Rome, Antibes, Moscow (1961); Tokyo, Kyoto, New York, Vigneux (1962); Moscow, Vallauris (1963); Cannes, Stockholm, Gentilly (1964); Saint-Paul de Vence, Saint-Etienne de Rouvray, Montrouge, Houston (1965); Marseilles, Chicago (1966); New York, Corbeil, Montreuil, Vitry-sur-Seine, Bobigny, Tel Aviv, Baden Baden, Saint Martin d'Herez (1967); Vienna, Budapest, Vincennes, Le Havre (1968); Rennes, Paris, Nîmes, Le Guilvinec, Bourges, Nanterre (1969).

Bibliography

WRITINGS BY LÉGER

Les Origines de la Peinture et sa valeur représentative, *Montjoie*, 1, 8, 9–10, Paris, 1913 (Notes for a lecture at the Académie Wassilieff the 5th May 1913); Réalisations picturales actuelles, *Soirées de Paris* 3, 25, Paris, 1914 (lecture given at Lyons at the Académie Wassilieff); Pensées, *Valori Plastici*, 1, 2–3, Rome, 1919; La Couleur dans la vie, *Promenoir*, 5, Lyons, 1921 (fragment of an essay on new plastic values); L'Esthétique de la Machine; l'Objet fabriqué, l'Artisan et l'Artiste, *Der Querschnitt*, 3, Berlin, 1923; Kurzgefasste Auseinandersetzung über das aktuelle Künstlerische Sein, *Das Kunstblatt*, 7, Berlin, 1923; Réponse à une enquête: Où va la Peinture moderne?, *Bulletin de l'Effort Moderne*, 2, Paris, 1924; Correspondance (with M. Leonce Rosenberg, in March 1922), *Bulletin de l'Effort Moderne*, 4, Paris, 1924; Le Spectacle, *Bulletin de l'Effort Moderne*, 7, 8, 9, Paris, 1924 (lecture given at the Sorbonne under the auspices of the Groupe d'Etudes philosophiques et scientifiques); Film by Léger and Dudley Murphy, Musical Synchronism by George Antheil, *Little Review*, 10, 2, New York, 1924; Vive Relâche, *Paris-Midi*, Paris, 17th December 1924; Le Ballet-Spectacle: l'Objet-Spectacle, *Bulletin de l'Effort Moderne*, 12, Paris, 1925; Les Bals populaires, *Bulletin de l'Effort Moderne*, 12, 13, Paris 1925; Sehr Aktuell Sein, *Europa Almanach*, Potsdam, Kiepenheuer, 1925; Conférence sur l'Esthétique de la Machine, au Collège de France, in Florent Fels, *Propos d'Artistes*, Paris, 1925; Notations on Plastic Values, in the catalogue of the Fernand Léger Exhibition, Anderson Galleries, New York, 1925; Peinture et Cinéma, *Cinéma*, Paris 1925; A New Realism–the Object (its Plastic and Cinematographic Value), *Little Review*, 11, 2, New York, 1926; Citation, in Maurice

Raynal, *Anthologie de la Peinture en France*, Paris, 1927; *Meine Berliner Ausstellung*, *Der Querschnitt*, 8, 1, Berlin, 1928; *La Rue: Objets, Spectacles, Cahiers de la République des Lettres, des Sciences et des Arts*, 12, Paris, 1928; Pensées sur l'Art, in W. GEORGE, *Fernand Léger*, Paris, 1929; Actualitiés, *Variétés*, 1, 9, Brussels 1929 (Lecture given in Berlin in March, 1928); A propos du Cinéma, *Plans*, 1, Paris, 1923; De l'Art abstrait, *Cahiers d'Art*, 6, 3, Paris, 1931; New York vu pa Fernand Léger, *Cahiers d'Art*, 6, 9–10, Paris, 1931; Introduction du *Catalogue* de l'exposition *Alexander Calder*, Galerie Percier, Paris, 1931; Chicago, *Plans*, 11, Paris, 1932; L'Art est entré en cambrioleur, *Mouvement*, 1, Paris, 1933, Discours aux Architectes, *Quadrante*, 5, Milan, 1933 (delivered on the occasion of the IVth International Congress of Modern Architecture); Le Beau et le Vrai, *Beaux-Arts*, 73, 58, Paris, 1934 (Part of a lecture given at Sorbonne under the title: De l'Acropole à la Tour Eiffel); Réponse a une Enquête: Que feriez-vous, si vous aviez à organiser l'Exposition de 1937?, *Vu*, 387, Paris, 1935; The New Realism; Lecture Delivered at the Museum of Modern Art, *Art Front*, 2, 8, New York, 1935; Réponse a une enquête sur l'Art d'aujourd'hui, *Cahiers d'Art*, 10, 1–4, Paris 1935; La Couleur et le sentiment, *Pour Vous*, 358, Paris, 1935; Painting and Reality, *Transition*, 25 New York, 1936; A propos of Colour, *Transition*, 26 New York, 1937; Sur la peinture, in *L'Exposition 1937 et Les Artistes à Paris*, Paris, 1937; L'Art mural de Victor Sevranckx, *Clarté*, 10, 7, Brussels, 1937; Revival of Mural Art, *The Listener*, 18, 450, London, 1938 (Translated by Douglas Cooper); Beauty in Machine Art, *Design*, 39, Columbus, Ohio, 1938; Preface to the catalogue of the *Fernand Léger* exhibition, Brussels, 1938; Couleur dans le Monde, in *L'Homme, la Technique, la Nature*, Paris, 1938; Réponse a une enquête; L'Acte créateur se ressent-il de l'influence des événements environnants . . ., *Cahiers d'Art*, 14, 14, Paris 1939; The question of truth, *Architectural Forum*, 70, New York, 1939; New York–Paris, Paris–New York, *La Voix de France*, 15 May 1941; Un Art nouveau sous le ciel californien, *La Voix de France*, 15 May, 1942; Découvrir l'Amérique, *La Voix de France*, 1 November, 1941; Byzantine Mosaics and Modern Art, *Magazine of Art*, 37, Washington D.C. 1944, Relationship between Modern Art and Contemporary Industry, in *Modern Art in Advertising:* an Exhibition of designs for Container Corporation of America, Chicago, 1945; A propos du corps human considéré comme un objet, in Fernand Léger, *La Forme humaine dans l'Espace*, Montreal, 1945; L'Oeil du peintre, *Variétés*, 3, Paris, 1945; Modern Architecture and Colour in *American Abstract Artists*, New York, 1946; Le Peuple et les Arts, *Bulletin de Travail et Culture*, 1946; Causeries sur l'Art, *Arts de France*, 6, 1946; Léger Fernand. L'Oeil du peintre, *Variété*, 3, Paris, 1946; Léger retrouve la France, *Arts de France*, 6, Paris, 1946; Témoignage, in *Pour et contre l'Art abstrait*, Paris, 1947; Color in Architecture, in STAMO PAPADAKI, *Le Corbusier*, New York, 1948; Que signifie: Etre témoin de son temps? *Arts*, 205, Paris, 11 March 1949; Un nouvel espace en architecture, *Art d'Aujourd'hui*, 3, Boulogne, 1949; L'Art abstrait, *Derrière le Miroir*, 20–21, Paris, 1949; Baumeister, *L'Age nouveau*, 44, 1949; Calder. Derrière le miroir, *Pierre à Feu*, 31, Paris, 1950; Le Cirque, Paris, 1950 (text in Léger's hand and 35 original lithographs); Situation de la Peinture dans le temps actuel, *Biennale*, 5, Venice, 1951; L'Architecture moderne et la couleur, *Formes et Vie*, 1 Paris, 1951; Témoignage: L'Espace, *XX Siècle*, 2, Paris, 1952; La Peinture moderne devant le monde actuel, *Lettres Françaises*, 5, 11, 405, Paris, 1952 (conference held at the Maison de la Pensée Française); Comment je conçois la figure, in *La Figure dans l'oeuvre de Léger*, Paris, 1952; Vers l'Architecture, in *Catalogue* Exposition L. Carré, Paris, 1953; Sens de l'Art moderne, *Zodiaque*, 18–19, Saint-Léger-Vauban, 1954; Réflexions sur l'intégration de la peinture et de la sculpture dans l'Architecture, *I 4 Soli*, 1, Turin, 1954; La vie fait l'oeuvre de Fernand Léger, *Cahiers d'Art*, 2, Paris, 1954 (essays collected by Dora Vallier); Les Mains des constructeurs, *Heures Claires*, 123, Paris, 1955 (a poem by Léger of 1951); Comment cela commence, *Les Lettres Françaises*, 528, Paris, 1955 (preface to *Fernand Léger*, by PIERRE DESCARGUES); Entretien de F.L. avec Blaise Cendrars et Louis Carré, sur Le Paysage dans l'oeuvre de Fernand Léger, Paris, 1956; Fonction de la Peinture, Paris, 1965.

INTERVIEWS WITH LÉGER

R. COGNIAT, Chez Fernand Léger, *Beaux-Arts*, 72, 16, Paris, 21st April 1933 (Léger replies to the questions raised in this article in *Beaux-Arts*, 72, 18, Paris, May 1933); Où va la peinture? (interview), *Commune*, 2, Paris, 1935; Pity us! (interview), *Art Digest*, 10, New York, 1935 (reprinted in the *New York Herald Tribune*); I . . ., P . . . Fernand Léger pendant son séjour en Amérique a fait des conférences à l'Université de Yale, *Beaux-Arts*, 76, 326, Paris, 1939; F. GROMAIRE, L'avenir est à la couleur, nous dit Fernand Léger peintre et cinéaste, *Ecran Français*, 4, 40, Paris, 1946; ANDRÉ WARNOD, L'Amérique ce n'est pas un pays, c'est un monde, dit Fernand Léger, *Arts*, 49, Paris, 4th January 1946; P. DESCARGUES, F. Léger (interview), *Arts*, 147, Paris, 2nd January 1948; Fernand Léger et ses élèves vont décorer l'Exposition Internationale des Femmes, *Arts*, 168, Paris, 28th May 1948; Doit-on réformer l'enseignement des Beaux-Arts, *Traits*, 4, Paris, 1948; RUSSEL W. HOWE, Chalk and cheese: Puy and Léger, *Apollo*, 50, London, 1949; I-P. FAVRE, Quel paysage avez-vous choisi? Fernand Léger: Jamais de la vie je n'irais dans le Midi, *Arts*, 367, Paris, 10th July 1952; Y. TAILLANDIER, Une enquête: L'Art et le climat visuel contemporain, Salon de Mai, *Catalogue*, 1952; M. MARCEAU, Interview avec Léger, *Magnum*, 3, Frankfurt/Main, 1954; R. BORDIER, Polychromie architecturale, *Aujourd'hui, Art et Architecture*, 2, 1955 (on the hospital at Saint-Lô).

BOOKS AND PERIODICALS

A. GLEIZES and J. METZINGER, *Du Cubisme*, Paris, 1912; R. ALLARD (Fernand Léger), *Soirées de Paris*, Paris, 1913; G. APOLLINAIRE, Les Peintres cubistes, *Méditations esthétiques*, Paris, 1913; U. BOCCIONI, Il dinamismo futurista e la Pittura Francese, *Lacerba*, 15, Florence, 1913; H. WALDEN, Les Origines de la peinture contemporaine et sa valeur représentative, *Der Sturm*, 4, 172–73, 1914; W. H. WRIGHT, *Modern Painting, its Tendency and Meaning*, New York, London, 1915; H. WALDEN, *Einblick in Kunst: Expressionismus, Futurismus, Kubismus*, 1917; B. CENDRARS, Les Peintres Cubistes, *Rose Rouge*, Paris, 1919; B. Cendrars, Construction, in *Dix-neuf Poèmes élastiques*, Paris, 1919; I. GOLL, Über Kubismus, *Das Kunstblatt*, 4, Potsdam, 1920; D-H. KAHNWEILER, *Der Weg zum Kubismus*, Munich, 1920; D-H. KAHNWEILER, Fernand Léger, *Der Cicerone*, 12, 19, Leipzig, 1920; M. RAYNAL, *Fernand Léger: Vingt tableaux*, Paris, 1920; A. SALMON, *L'Art vivant*, Paris, 1920; *Collection Daniel-Henry Kahnweiler* (sale catalogue), Paris, 1920; I. GOLL, Fernand Léger, *Das Kunstblatt*, 6, Potsdam, 1922; L. KASSAK and L. MOHOLY-NAGY, *Buch neuer Künstler*, Vienna, 1922; B. CENDRARS, *La Création du Monde*, ballet by Borlin, Cendrars, Léger, Milhaud, *L'Esprit Nouveau*, 2, Paris, 1923; J. EPSTEIN, Fernand Léger, *Feuilles Libres*, 31, Paris, 1923; J. GORDON, *Modern French Painters*, New York, 1923; M. RAYNAL, *Skating-Rink*, ballet by Léger, Esprit Nouveau, 2, Paris, 1923; J. BADOVICI, Projet décoratif et Fresques par F. Léger, *Architecture Vivante*, Paris, 1924; H. HILDEBRANDT, *Die Kunst des 19. und 20. Jahrhunderts*, Wildpark-Potsdam, 1924; F. FELS, *Propos d'Artistes*, Paris, 1925; L. LOZOWICK, Fernand Léger, *The Nation*, 121, New York, 1925; K. S. DREIER, *Modern Art*, New York, 1926; C. EINSTEIN, *Die Kunst des 20. Jahrhunderts*, Berlin, 1926; W. GEORGE, Fernand Léger, *Amour de l'Art*, 7, Paris, 1926; R. KURTZ, *Expressionismus und Film*, Berlin, 1926; M. RAYNAL, Fernand Léger, *Cahiers d'Art*, 1, Paris, 1926; A. WARNOD, *Les Berceaux de la jeune peinture*, Paris, 1926; S. GASCH, Fernand Léger, *L'Ami des Arts*, 2, 10, Sitges, 1927; W. GEORGE, Lettre de Berlin, *Art Vivant*, 3, Paris, 1927; J. MAUNY, Paris Letter, *The Arts*, 2, New York, 1927; M. RAYNAL, *Anthologie de la Peinture en France*, Paris, 1927; C. ZERVOS, Nouvelles Peintures de Fernand Léger, *Cahiers d'Art*, 2, Paris, 1927; W. Grohmann, Léger, in Thieme and Becker, *Allgemeines Lexikon der bildenden Künstler*, Leipzig, 1928; E. TERIADE, *Fernand Léger*, Paris, 1928; W. UHDE, *Picasso et la tradition française: Notes sur la Peinture actuelle*, Paris, 1928; A. BASLER, Le Cafard après la fête, Paris, 1929; R. COGNIAT, Décors de Fernand Léger, *Chroniques du Jour*, 3 Paris, 1929; P. FIERENS, Fernand Léger, *La Renaissance*, 12, Paris, 1929; W. GEORGE, *Fernand Léger*, Paris, 1929; G. JANNEAU, *L'Art cubiste*, Paris, 1929; A. OZENFANT, *Art*, Paris, 1929; *Sélection*, série n. 3, 8, 5, Antwerp 1929; E. TERIADE, Documentaire sur la jeune Peinture: l'Avènement classique du Cubisme, *Cahiers d'Art*, 4, Paris, 1929; C. ZERVOS, Fernand Léger et le développement des Objets dans l'Espace, *Cahiers d'Art*, 4, Paris, 1929; P. BERTHELOT, L'Atelier de Fernand Léger, *Beaux-Arts*, 8, Paris, 20th December 1930; C. EINSTEIN, Léger: Oeuvres récentes, *Documents*, 2, 4, Paris, 1930; W. GEORGE, Fernand Léger, Triomphe et Misère d'une victoire, *Formes*, 7, Paris, 1930; L. GOODRICH, Léger, *Arts*, 17, New York, 1930; C. ZERVOS, De l'Importance de l'Objet dans la Peinture d'aujourd'hui, *Cahiers d'Art*, 5, Paris, 1930; GERMAIN BAZIN, Fernand Léger ou l'Effort moderne, *Amour de l'Art*, 12, Paris, 1931; R. HOPPE, Fransk genombrottkonst under nitton-hundratalet, *Ord och Bild*, 40, Stockholm, 1931; A. KORMENDI, Fernand Léger, *Creative Art*, 9, New York, 1931; G. L. K. MORRIS, On Fernand Léger and Others, *The Miscellany*, 1, 6, New York, 1931; M. RAYNAL, De La Fresnaye à Fernand Léger, *Plans*, 1, Paris, 1931; J. J. SWEENEY, Léger and the Cult of the Close-Up, *Arts*, 17, New York, 1931; J. J. SWEENEY, *Creative Art*, 9, New York, 1931; E. TERIADE, Léger, in EDOUARD-JOSEPH, *Dictionnaire biographique des Artistes Contemporains 1910–1930*, Paris, 1931; K. BOND, Léger. Dreyer and Montage, *Creative Art*, 11, 2, New York, 1932; W. GEORGE, Genèse d'une Crise, *Amour de l'Art*, 13, 1931; J. J. SWEENEY, Léger and Cinesthetic, *Creative Art*, 10, New York, 1932; C. ZERVOS, Une nouvelle étape dans l'Oeuvre de Fernand Léger: Gouaches et Dessins colorés, *Cahiers d'Art*, 7, 6–7, Paris, 1932, *Cahiers d'Art*, 8, 3–4, Paris, 1933; R. COGNIAT, Le Cubisme méthodique; Léger et l'Effort moderne, *Amour de l'Art*, 14, Paris, 1933; P. DU COLOMBIER and R. MANUEL, *Les Arts*, Paris, 1933; H. READ, *Art Now*, New York, 1933; J. J. SWEENEY, *Plastic Redirections in 20th Century Painting*, Chicago, 1934; C. ZERVOS, Fernand Léger et la poésie de l'objet, *Cahiers d'Art*, 9, 1, Paris, 1934; French painter exhibits some new angles on old planes, *Newsweek*, 6, New York, 1935; R. HUYGHE, *Histoire de l'Art contemporain: La Peinture*, Paris, 1935; G. L. K. MORRIS, Fernand Léger, versus cubism, *Bulletin of the Museum of Modern Art*, 3, 1, New York, 1935; *Collection Jacques Zoubaloff* (sale catalogue), Paris, 1935; B. GREENE, The Function of Léger, *Art Front*, 2, 9, New York, 1936; P-G. BRUGUIÈRE, L'Exposition Fernand Léger, *Nouvelle Revue Française*, 48, Paris, 1937; R. ESCHOLIER, *La Peinture Française, XXe siècle*, Paris, 1937; P. NELSON, Peinture spatiale et Architecture; à propos des dernières oeuvres de Léger, *Cahiers d'Art*, 12, Paris, 1937; New York University acquires outstanding painting by Léger: the City, *Art News*, 35, New York, 1937; C. ZERVOS, *Histoire de l'Art contemporain*, Paris, 1938; B. CHAMPIGNEULLE, *L'Inquiétude dans l'Art d'aujourd'hui*, Paris, 1939; L. CHERONNET, L'Expression murale chez Fernand Léger, *Art et Décoration*, 2, Paris, 1939; M. JOUHANDEAU, Making raids on faces, *Verve*, 2, 5–6, 1939; R. HUYGHE, *La Peinture française: Les Contemporains*, Paris, 1939; H. MADSEN, *From Symbolism to Surrealism*, Stockholm, 1939; R. MARTIENSSEN, Architecture in Modern Painting, *South African Architectural Record*, 24, 3. Johannesburg, 1939; J. FOLLAIN, Fernand Léger, *Cahiers d'Art*, 15, 1–2, Paris, 1940; Collection Albert E. Gallatin, *Museum of Living Art*, A. E. Gallatin Collection, New York, 1940; J. PAINLEVE, A propos d'un nouveau Réalisme chez Fernand Léger, *Cahiers d'Art*, 15, 3–4, Paris, 1940; R. HOWARD WILENSKI, *Modern French Painters*, New York, 1940; WALTER P. CHRYSLER JR., *Collection*, Richmond, 1941; S. JANIS, School of Paris comes to U.S., *Decision*, 2, 5–6, New York, 1941; Muralist, *New Yorker*, 16, New York, 4th January 1941; J. J. SWEENEY, Léger: classicist, *Norte*, 1, 9, New York, 1941; Twelve Artists in U.S. exile, *Fortune*, 24, New York, 1941; M. FARBER, Two European Painters, *New Republic*, 107, New York, 1942; M. GEORGES-MICHEL, *Peintres et Sculpteurs que j'ai connus*, New York, 1942; R. MARTIENSSEN, Fernand Léger in Paris–1938, *South African Architectural Record*, Johannesburg, August 1942; J. E. PAYRO, *Pinura Moderna*, Buenos-Aires, 1942; T. STOCKO, Recent Accession . . . Bird Woman, *St. Louis Museum Bulletin*, 27, 1942; J. J. SWEENEY, Today's Léger-Demain: Famous French Abstractionist's Work in his Two Year American Exile, *Art News*, 41, New York, 1942; Léger, in *Current Biography*,

New York, 1943; B. DORIVAL, *Les Etapes de la Peinture française contemporaine*, Paris, 1944; M. GEORGES-MICHEL, *Les Grandes Epoques de la Peinture moderne*, New York-Paris, 1944; A. SKIRA, Ed., *Anthologie du Livre illustré par les Peintres et les Sculpteurs de l'Ecole de Paris*, Geneva, 1944; J. J. SWEENEY, Léger and the Search for Order, *View*, 4, 3, New York, 1944; J. BAZAINE, *Fernand Léger, Peintures antérieures à 1940*, Paris, 1945; E. BILLE, *Picasso, Surréalisme, Abstrakt Kunst*, Copenhagen, 1945; E. BONFANTE and J. RAVENNA, *Arte Cubista*, Venice, 1945; Ecole de Paris à New York, special number of *Amour de l'Art*, 2, Paris, 1945; FERNAND LÉGER, *La Forme Humaine dans l'espace*, Montreal, 1945; M. GEORGE-MICHEL, *Chefs-d'oeuvre de Peintres contemporains*, New York, 1945; S. GIEDION, Léger in America, *Magazine of Art*, 38, Washington D.C., 1945; P. LOEB, *Voyages à travers la peinture*, Paris, 1945; G. AMBERG, *Art in Modern Ballet*, New York, 1946; G. BESSON, Fernand Léger, *Pages Françaises*, 13, Paris, 1946; L-G. CLAYEUS, Le Retour de Léger, *Les Arts et les Lettres*, 2, 6, Paris, 1946; D.-H. KAHNWEILER, *Juan Gris*, Paris, 1946; L. MOHOLY-NAGY, *Vision in Motion*, Chicago, 1946; L. MOUSSINAC, Fernand Léger retrouve la France, *Arts de France*, 6, Paris, 1946; Oeuvres executées aux Etats-Unis, *Cahiers d'Art*, 20–21, Paris, 1946; J. J. SWEENEY, Eleven Europeans in America, *Museum of Modern Art Bulletin*, 13, 4–5, New York, 1946; A. WATT, The Art World of Paris, *Studio*, 132, 1946; M. A. COUTURIER, *A Modern Church at Assy*, New York, 1947; P. ELUARD, A Fernand Léger, *Cahiers du Sud*, 34, 285, Marseilles, 1947; D. WALLARD, Georges Braque et Léger à Avignon, *Poésies 47*, 41, Paris, 1947; S. ALFONS, Léger vid Skiljovagen, *Konstrevy*, 24, 4–5, Stockholm, 1948; C. BIEDERMAN, *Art as the Evolution of visual Knowledge*, Red Wing, Minn., 1948; M. A. COUTURIER, L'Eglise d'Assy, *Arts*, 12, Paris, 1948; M. DAVIDSON, *An Approach to Modern Painting*, New York, 1948; R. DAVIS, Institute Acquires Painting by Léger . . . Table and Fruits, *Minneapolis Institute Bulletin*, 37, Minneapolis, 1948; F. ELGAR, *Léger, Peintures, 1911–1948*, Paris, 1948; L. GISCHIA, Léger, in B. DORIVAL, *Les Peintres Célèbres*, Geneva, Paris, 1948; C. GREENBERG, The Painter's Conflict, in S. M. KOOTZ, *Women*, New York, 1948; W. HAFTMANN, Neues von Fernand Léger, *Tagebuch*, 3–4, Dusseldorf, 1948; P. KRAUS, Constructie der Schoonheid, *Kronick von Kunst en Kultuur*, 9, 4, Amsterdam, 1948; *Miller Company Collection*, text by H-R. HITCH-COCK, New York, 1948; H. READ, *Art Now*, London, 1948; M. ARLAND, Léger, *Chronique de la Peinture moderne*, Paris, 1949; Artistes chex eux vus par Mayvald, *Architecture d'Aujourd'hui: Arts Plastiques*, Boulogne, 1949; AUDIBERTI, Fernand Léger est un phénomène historique, *Arts*, 231, Paris, 1949; J. CASSOU, Fernand Léger, *Art News*, 48, New York, November 1949; D. COOPER, *Fernand Léger et le nouvel espace*, Geneva, 1949; G. HILAIRE, *Les Lauriers inutiles*, Paris, 1949; G. HILAIRE, Visite à Fernand Léger, *Pour l'Art*, 6, Lausanne, 1949; L. DEGAND, F. Léger, *Art d'Aujourd'hui*, 1, 3, Boulogne, 1949; FERNAND LÉGER, *Architecture d'Aujourd'hui*, 20–22, Paris, 1949; GUILLEVIC, Sur des figures de Fernand Léger, *Cahiers d'Art*, 24, 1, Paris, 1949; M. JARDOT and K. MARTIN, *Les Maîtres de la Peinture Française Contemporaine*, Baden-Baden, 1949; W. BAUMEISTER and C. GREENBERG, Fernand Léger, *L'Age Nouveau*, 42, Paris, 1949; J. CASSOU, *Situation de l'Art moderne*, Paris, 1950; B. DENVIR, Painter of modern industrial forms, *Studio*, 140, London, 1950; Fragment d'un décor pour Bolivar, *Art d'Aujourd'hui*, 10–11, Boulogne, 1950; De Picasso au Surréalisme, in *Histoire de la Peinture Moderne*, Geneva, 1950; D-H. KAHNWEILER, Fernand Léger, *Burlington Magazine*, 5, 92, London, 1950; London. Una personale di Fernand Léger, *Emporium*, 112, 1950; G. MARCHIORI, *Pittura moderna in Europa*, Venice, 1950; Memorial de Bastogne, Belgium. Mosaiques de Fernand Léger, *Art d'Aujourd'hui*, série n. 2, 1, Boulogne, 1950; J. PIERRE, Fernand Léger: Aquarelles de Deauville, *Arts de France*, 33, 1950; M. RAYNAL, Fernand Léger, *Carreau*, 4, Lausanne, 1950; D. SUTTON, Léger at the Tate, *Art News and Review*, 2, 2, London, 1950; D. SYLVESTER, Portrait of the artist: Fernand Léger, *Art News and Review*, 2, 2, London, 1950; Audincourt, *L'Art Sacré*, 3–4, Paris, 1951; P. BARLATIER, F. Léger établit un dialogue entre lui et le public, *Ce soir*, 2nd June 1951; Le Cirque de Fernand Léger, *Domus*, 258, Milan, 1951; M. DIONISIO, *Encontros em Paris; F. Léger um jovem de 68 anos*, Lisbon, 1951; F. ELGAR, Les Constructeurs de F. Léger, *Carrefour*, 12th June 1951; C. ESTIENNE, De Gauguin à Léger, *Observateur*, 7th June 1951; C. ESTIENNE, Léger, où l'éspace des hommes, *Arts*, 15th June 1951; FERNAND LÉGER. *Les Constructeurs*, Paris, 1951; P. FRANCASTEL, *Peinture et Société*, Lyons, 1951; R. V. GINDERTAEL, F. Léger, *Art d'Aujourd'hui*, 3, 1, Boulogne, 1951; H.H., Der Maler Fernand Léger, *Kunst*, 49, 1951; H. HILDE-BRANDT, Der Maler Fernand Léger, *Die Kunst und das Schöne Heim*, 49, 7, Munich, 1951; RENÉ LACÔTE, F. Léger, *Parallèle*, Paris, 1951; Léger, *Svizzera Italiana*, 14 and 17–18, 1951; H. MCBRIDE, Léger, *Arts News*, 50, 2, New York, 1951; J. MAR-CENAC, F. Léger et les ouvriers de la Beauté, *Lettres Françaises*, June 1951; G. VER-ONESI, Fernand Léger, *Emporium*, 114, 1951; Waldmalerei von Fernand Léger im Französischen Pavillon, Triennale, Milan, *Werk*, 38, Zurich, 1951; C. ZERVOS, A propos des Constructeurs de Fernand Léger, *Cahiers d'Art*, 26, Paris, 1951; B.J. (JEAN BAZAINE), Une nouvelle interpretation de l'homme, *Arts*, 363, 12th June 1952; Baked Brightness, *Time*, 59, New York, 21st January 1952; J. BOURET, Léger, in E. BENEZIT, *Dictionnaire critique des peintres*, Paris, 1952; L. CARRÉ, *La Figure dans l'oeuvre de Léger*, Paris, 1952; L. DEGAND, Capire Fernand Léger, *Biennale*, 8, Venice, 1952; R. V. GINDERTAEL, La figure dans l'oeuvre de Fernand Léger, *Arts d'Aujourd'hui*, série n. 3, 2, Boulogne, 1952; R. V. GINDERTAEL, Sculptures polychromes, *Arts d'Aujourd'hui*, série n. 3, 2, Boulogne, 1952; P. M. GRAND, Céramiques de peintres, *Art et Décoration*, 30, Paris, 1952; A. MAUROIS, Mon ami Léger, in L. CARRÉ, *La figure l'oeuvre de Léger*, Paris, 1952; C. STERLING, *La Nature morte de l'antiquité à nos jours*, Paris, 1952; C. ZERVOS, *Fernand Léger: oeuvres de 1905 1952*, Paris, 1952; J. CASSOU, Développement de l'art de Léger, *La Revue des Arts*, 1, Paris, 1953; Le Cubisme, *Art d'Aujourd'hui*, série n. 4, 3–4, Boulogne, 1933; F. ELGAR, Les Sculptures polychromes de Léger, *Arts*, Paris, 21st January 1953; P. IMBOURG, Fernand Léger, *L'Amateur d'Art*, 118, Paris, 1953; M. JARDOT, *Dessins*, Paris, 1953; K. KUH, *Léger*, Chicago, Urbana, 1953; D. MILHAUD, Divertissements variés, *Magazine of Art*, 46, 2, 1953; K. REXROTH, Fernand Léger: master mechanic, *Art News*, New York, 1953; F. ELGAR, *Picasso et Léger, 2 Hommes, 2 Mondes*, Paris,

1954; F. ELGAR, Léger, in *Dictionnaire de la Peinture Française*, Paris, 1954, Erweiterung der Kirche von Courfaivre, *Werk*, Winterthur, December 1954; M. GEORGES-MICHEL, *De Renoir à Picasso, les peintres que j'ai connus*, Paris, 1954; R. V. GINDERTAEL, Fernand Léger propose l'art populaire de notre époque, *Les Beaux-Arts*, Bruxelles, 19th November, 1954; W. HAFTMANN, *Malerei im 20. Jahrhundert*, Munich, 1954; R. MAUNOURY, Peut-on miser sur un peintre moderne?, *Nouveau Femina*, Paris, October 1954; The Gift of a Léger, *Carnegie Magazine*, Pittsburg, 1954; A. VERDET, Léger ou la joie de vivre, *Défense de la Paix*, 42, Paris, 1954; N. WALDEN and L. SCHREYER, *Der Sturm*, Baden-Baden, 1954; Wie weiter? Fernand Léger, *Magnum*, 3, Frankfurt am Main, 1954; C. ZERVOS, Fernand Léger, La Grande Parade, *Cahiers d'Art*, Paris, 1954; Audincourt, *Nefs et Clochers*, Paris, 1955; A. H. BARR Jr. and W. S. LIEBERMANN, *Les Maîtres de l'Art moderne*, Paris, Brussels, Amsterdam, 1955; G. BEAUQUIER, Fernand Léger, peintre, *La Nouvelle Critique*, 7, 68, Paris, 1955; M. BERGER, Fernand Léger ou le mythe de la machine, *Preuves*, 56, Paris, 1955; J-A. CARTIER, Fernand Léger, ouvrier de la vie moderne, *Jardin des Arts*, 12, Paris, 1955; F. CHARLES, Fernand Léger, *Le Courrier Graphique*, 79, Paris, 1955; A. CHASTEL, Fernand Léger, la manière forte en peinture, *Le Monde*, Paris, 19th August 1955; C. CHONEZ, Dernière journée avec Fernand Léger, *Nouvelles Litteraires*, Paris, 25th August 1955; D. COOPER, La Grande Parade de Fernand Léger, *L'Oeil*, 1, Paris, 1955; J. DELOT, Fernand Léger, un primitif d'un âge nouveau, *Quatrième Internationale*, 13, 11–12, Paris, 1955; R. DEROUDILLE, Hommage à Fernand Léger, *I 4 Soli*, Alba, July–August 1955; P. DIVONNE, L'Eglise et la politique artistique de l'Etat, *L'Art Sacré*, 7–8, Paris, 1955; L-P. FAVRE, Léger sera toujours vivant, *Combat*, Paris, 9th August 1955; J-L. FERRIER, Léger et la civilisation technicienne, *Les Temps Modernes*, 116, Paris, 1955; R. V. GINDERTAEL, Fernand Léger, 1881–1955, *Les Beaux-Arts*, Brussels, 30th September 1955; R. V. GINDERTAEL, Fernand Léger, Oeuvres récentes 1953–1954, *Cimaise*, 2, 3, Paris, 1955; P. GUEGUEN, Fernand Léger, *Aujourd'hui*, Boulogne, September 1955; Hommage à Fernand Léger, *Les Lettres Françaises*, 582, 1955; Hommage à Fernand Léger, *Pour l'Art*, 44 Lausanne, 1955; La Vie d'un Peintre, Fernand Léger, *L'Oeil*, 10, Paris, 1955; J-J. LERRANT, De Fernand Léger à Le Corbusier, *Résonances Lyonnaises*, 30, 1955; J-J. LERRANT, Fernand Léger, premier méchanicien de la peinture, *Résonances Lyonnaises*, special no. Festival de Lyon-Charbonnières, 1955; GUNTHER BUCHHEIM LOTHAR, Fernand Léger, Menschen und Objekte, *Zeichnunger*, Feldafing Oberbayern, 1955; J. MELLQUIST, Landokap av Léger, *Vardlo Horisont*, 4, Goteborg, 1955; G. PEILLEX, Fernand Léger a réalisé dans l'église de Courfaivre une oeuvre magistrale, *Journal de la Maison Ch. Veillon*, 11, 4, Lausanne, 1955; P. REVERDY, Pour tenir tête à son époque, *Derrière le Miroir*, 79–80–81, Paris, 1955; A. DE RIDDER, In Memoriam, *Bulletin de l'Acad mie Royale des Sciences, Lettres et Beaux-Arts de Belgium*, 22, Brussels, 1955; J. J. SWEENEY, Fernand Léger: simple and solid, *Art News*, 54, 6, New York, 1955; E. TRIOLET, Le Gros Tilleul, *Heures Claires*, 123, Paris, 1955; A. VERDET, *Fernand Léger*, Paris, 1955; B. CENDRARS, *Entretiens avec Fernand Léger et Louis Carré*, Paris, 1956; D. COOPER, *Fernand Léger, Dessins de guerre. 1915–1916*, Paris, 1956; F. FOSCA, *Bilan du Cubisme*, Paris, 1956; P. FRANCASTEL, *Histoire de la Peinture Française, du classicisme au cubisme*, 2, Parigi-bruxelles, 1956; M. HUGGLER, Die Sammlung Hermann und Margrit Rupf, *Du*, 3, Zurich, 1956; M. JARDOT, *Fernand Léger*, Paris, 1956; M. JARDOT, Hommage à Léger, *Salon de Mai*, 1956; F. MATHEY, Léger et l'Art dit décoratif, *Jardin des Arts*, 20, Paris, 1956; H. PARMELIN, *Cinq Peintres et le Théâtre, Léger, Coutaud, Gischia, Labisse, Pignon*, Paris, 1956; A. VERDET, *Fernand Léger*, Geneva, 1956; R. DELEVOY, *Léger*, Skira Zwemmer, 1962; R. GARAUDY, *Pour un réalisme du XX^ième siècle*, Paris, 1968; R. DEROUDILLE, *Fernand Léger*, Paris, 1968, London, 1969; P. DE 'FRANCIA, *Léger: The Great Parade*, London, 1969.